DRAWING DYNAMIC
MANGA
CHARACTERS
The Easy 1-2-3 Method for Beginners

TOMOMI MIZUNA
JUNKA MOROZUMI

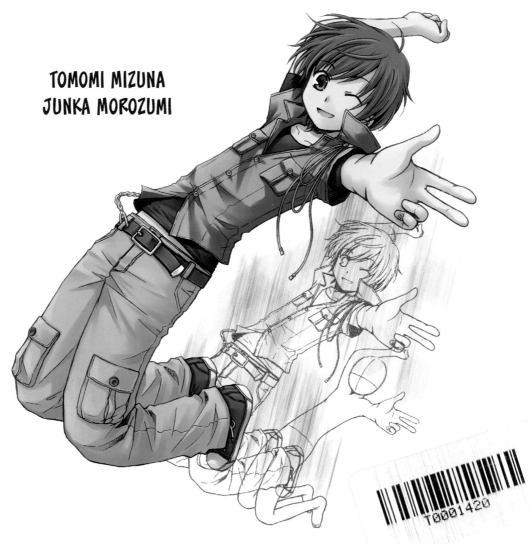

TUTTLE Publishing

Tokyo | Rutland, Vermont | Singapore

CONTENTS

CHAPTER 1 Basic Expressions

CHAPTER 2 Adding Emotions

HOW CAN I MAKE MY CHARACTERS MORE DYNAMIC?

Since publishing *The Manga Artist's Handbook: Drawing Basic Manga Characters*, this is the question readers have most frequently asked. The focus of that guide was on the basics: proportion, framing, blocking-in and the various poses manga artists need to master. The goal was to give beginning manga artists an understanding of balance and composition, by tracing the blocked-in drawings in their own style.

Now you manga maniacs want to stretch your skills, creating characters with more animated expressions and more complex poses. As with our other manual, the guiding principle here is the same, follow the tips and learn the techniques all while applying and developing your own style.

No matter what your character is doing, the entire body is involved. Elation, dejection, fear, emotions are felt and expressed in the entire body, and now you can capture these nuances and details with realism and clarity. Expression is not reserved for the face alone, so mastering motion and movement is essential to elevating your personal style. Learn the ropes while adapting these tips and techniques to your own vision and the story only you—and your characters!—can tell.

Compelling and complex poses and eloquently expressive faces are now as easy as 1, 2, 3. Trace the faces, fill in the bodies, then add the details, the embellishments and finishing touches only you can include when creating a manga universe all your own.

What Is Blocking-In?

⭐ **Blocking-in** means roughly sketching an outline or a form in order to flesh out a character's shape and pose. Professional manga artists and illustrators don't just dash off a polished, finished artwork. Instead, they create a rough sketch, which they then go back over in pencil before adding color and refining the illustration in pen. The lines used while blocking-in are faint, so they can be easily erased, making it simple to correct the figure's positioning or to rethink poses. Blocking-in is invaluable when drawing characters' signature poses or when fitting multiple characters into a single cell or frame.

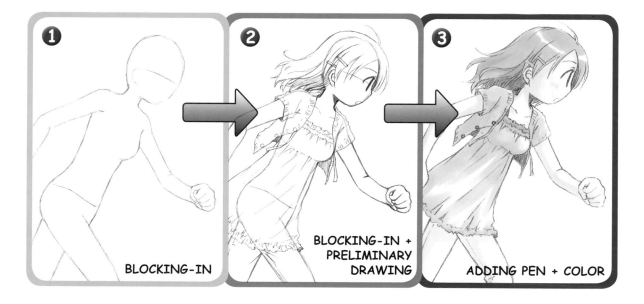

❶ BLOCKING-IN

❷ BLOCKING-IN +
PRELIMINARY
DRAWING

❸ ADDING PEN + COLOR

DRAWING MANGA
IS NOT A RACE BUT
A STEADY PROGRESSION
OF PENCIL STROKES UNTIL
YOU GET THE POSE AND
EXPRESSION JUST RIGHT!

HERE'S WHAT HAPPENED
WHEN WE TRIED DRAWING
VARIOUS SCENES...

SEE THE NEXT PAGE!

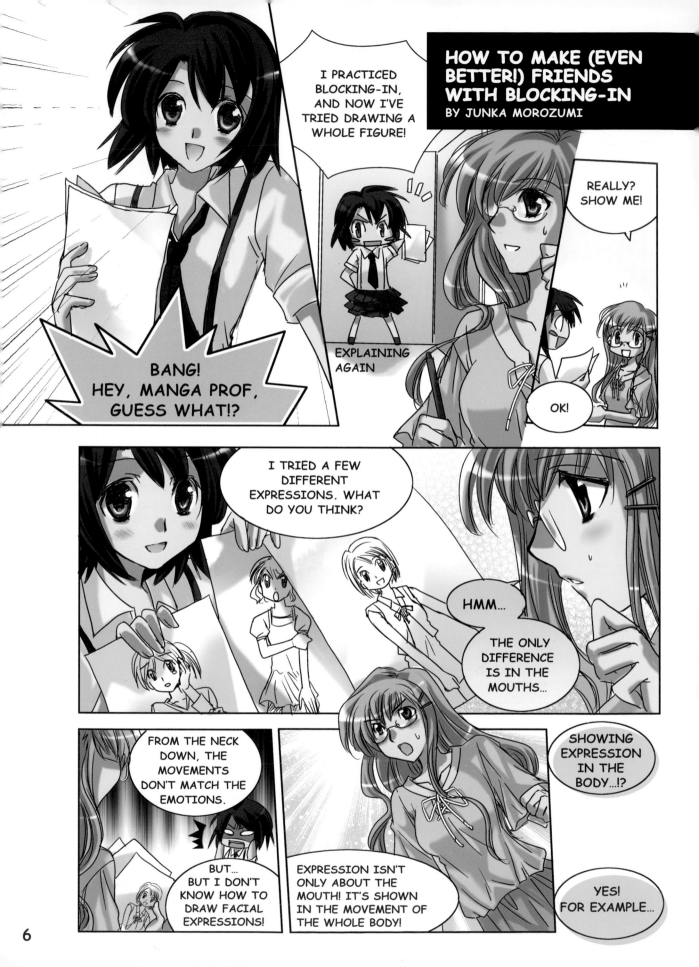

I PRACTICED BLOCKING-IN, AND NOW I'VE TRIED DRAWING A WHOLE FIGURE!

HOW TO MAKE (EVEN BETTER!) FRIENDS WITH BLOCKING-IN
BY JUNKA MOROZUMI

REALLY? SHOW ME!

EXPLAINING AGAIN

OK!

BANG! HEY, MANGA PROF, GUESS WHAT!?

I TRIED A FEW DIFFERENT EXPRESSIONS. WHAT DO YOU THINK?

HMM...

THE ONLY DIFFERENCE IS IN THE MOUTHS...

SHOWING EXPRESSION IN THE BODY...!?

FROM THE NECK DOWN, THE MOVEMENTS DON'T MATCH THE EMOTIONS.

BUT... BUT I DON'T KNOW HOW TO DRAW FACIAL EXPRESSIONS!

EXPRESSION ISN'T ONLY ABOUT THE MOUTH! IT'S SHOWN IN THE MOVEMENT OF THE WHOLE BODY!

YES! FOR EXAMPLE...

CLASPING THE HANDS IN FRONT OF THE FACE DEPICTS FALLING IN LOVE.

ADDING CLENCHED FISTS TO A SMILING FIGURE MAKES FOR AN ENERGETIC, POWERFUL LOOK!

DOWNCAST EYES AND ARMS WRAPPED AROUND THE BODY SHOW UNEASE AND LONELINESS.

YOU'RE RIGHT! I CAN SHOW EXPRESSION IN THE BODY, NOT JUST THE FACE!

DEEP BREATHS

SEE? THESE POSES HELP TO CONVEY THE EMOTIONS MORE FULLY THAN IF YOU'D JUST DRAWN THE FACE.

SO THIS TIME, PRACTICE USING THE BODY AND THE FACE TO SHOW EXPRESSION.

OK!

FIRST OF ALL, I'LL TRY THE "FALLING IN LOVE" POSE!

GETTING THE WRONG IDEA!

DON'T LOOK AT ME AS YOU SAY THAT!

Gallery of Expressions

This chart allows you to use facial expressions to search for the poses you want to draw. It is roughly color-coded into emotional genres.

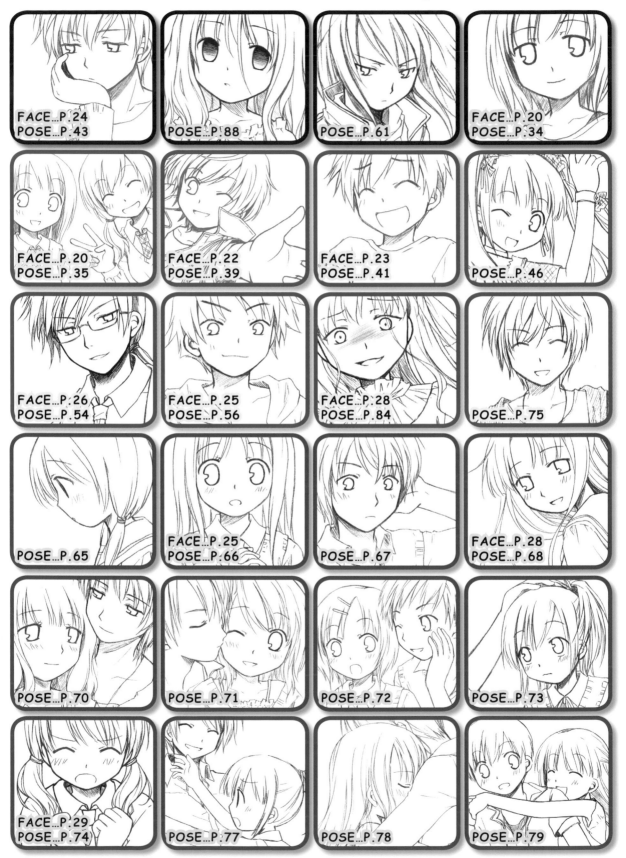

FACE...P.24
POSE...P.43

POSE...P.88

POSE...P.61

FACE...P.20
POSE...P.34

FACE...P.20
POSE...P.35

FACE...P.22
POSE...P.39

FACE...P.23
POSE...P.41

POSE...P.46

FACE...P.26
POSE...P.54

FACE...P.25
POSE...P.56

FACE...P.28
POSE...P.84

POSE...P.75

POSE...P.65

FACE...P.25
POSE...P.66

POSE...P.67

FACE...P.28
POSE...P.68

POSE...P.70

POSE...P.71

POSE...P.72

POSE...P.73

FACE...P.29
POSE...P.74

POSE...P.77

POSE...P.78

POSE...P.79

Emotions color key:

NO EXPRESSION	HAPPINESS/ LAUGHTER	EXCITEMENT/ AFFECTION	RAGE/ REGRET	SADNESS/ GRIEF	SURPRISE/FEAR/PAIN

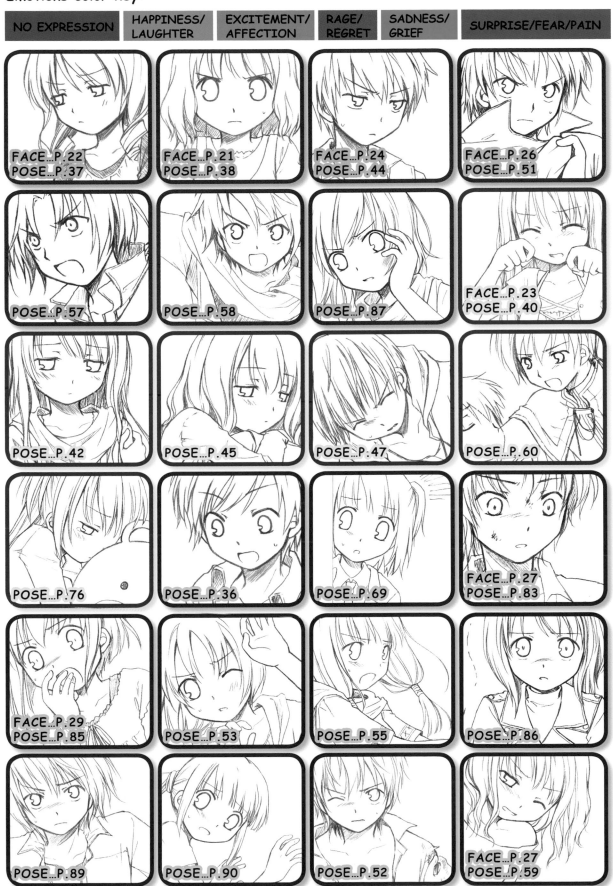

FACE...P.22
POSE...P.37

FACE...P.21
POSE...P.38

FACE...P.24
POSE...P.44

FACE...P.26
POSE...P.51

POSE...P.57

POSE...P.58

POSE...P.87

FACE...P.23
POSE...P.40

POSE...P.42

POSE...P.45

POSE...P.47

POSE...P.60

POSE...P.76

POSE...P.36

POSE...P.69

FACE...P.27
POSE...P.83

FACE...P.29
POSE...P.85

POSE...P.53

POSE...P.55

POSE...P.86

POSE...P.89

POSE...P.90

POSE...P.52

FACE...P.27
POSE...P.59

Combine Expressions and Poses for Amazing Illustrations!

★ **Emotions** Happiness, anger, sadness, anticipation: the nuances of these emotions can be hard to capture. There's a lot of appeal in an illustration that can convey in an instant what a character is feeling!

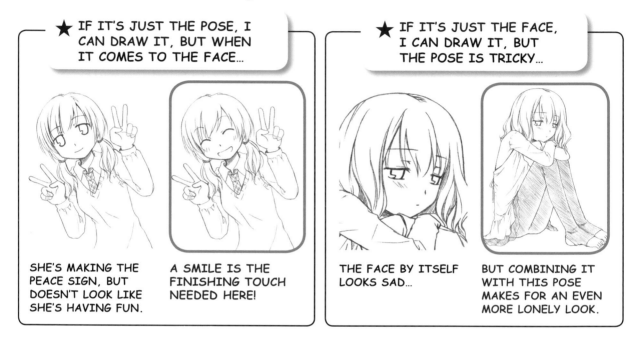

★ IF IT'S JUST THE POSE, I CAN DRAW IT, BUT WHEN IT COMES TO THE FACE...

★ IF IT'S JUST THE FACE, I CAN DRAW IT, BUT THE POSE IS TRICKY...

SHE'S MAKING THE PEACE SIGN, BUT DOESN'T LOOK LIKE SHE'S HAVING FUN.

A SMILE IS THE FINISHING TOUCH NEEDED HERE!

THE FACE BY ITSELF LOOKS SAD...

BUT COMBINING IT WITH THIS POSE MAKES FOR AN EVEN MORE LONELY LOOK.

In other words......

★ **Emotion is conveyed through both the face and the body!**

This book is broadly divided into two sections: a log of facial expressions to practice and a collection of blocked-in poses. For those who are not confident drawing faces, it's best to start with the practice in Chapter 1 to get a grip on the basic emotional expressions, then go to the collection of blocked-in poses in Chapters 2 through 5. Readers who want to practice poses using the entire figure can try starting with these chapters.

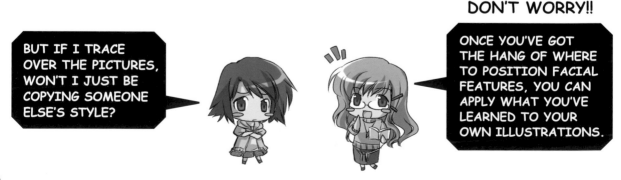

BUT IF I TRACE OVER THE PICTURES, WON'T I JUST BE COPYING SOMEONE ELSE'S STYLE?

DON'T WORRY!!

ONCE YOU'VE GOT THE HANG OF WHERE TO POSITION FACIAL FEATURES, YOU CAN APPLY WHAT YOU'VE LEARNED TO YOUR OWN ILLUSTRATIONS.

How to Trace the Blocked-In Parts

⭐ When tracing over the blocking-in, there are two methods that can be used. One involves tracing exactly over the top of the blocking-in itself, while the other involves tracing just inside (or just outside) the blocking-in. Choose whichever method works best for your personal style.

Size of the Face

THIS VERSION SHOWS THE TRACING EXACTLY OVER THE TOP OF THE BLOCKING-IN. THE FACE IS THE SAME SIZE AS THE BLOCKING-IN.

HERE, THE FACE IS SLIGHTLY SMALLER THAN THE BLOCKING-IN. THE EARS FIT WITHIN THE BLOCKED-IN OUTLINE.

⭐ KIDS MAKING FUNNY FACES

MAKE THE FACE WIDER THAN THE BLOCKING-IN

⭐ DIAGONAL OVERHEAD VIEW

THE BLOCKING-IN LINES CURVE

⭐ DIAGONAL VIEW FROM BELOW

PAY ATTENTION TO THE DIRECTION OF THE CURVE

The Line of the Body

Blocking-in

⭐ TRACING DIRECTLY OVER THE BLOCKING-IN PRODUCES A STURDY PHYSIQUE.

⭐ DRAWING INSIDE THE BLOCKING-IN LINES ON THE NECK AND SHOULDERS MAKES FOR A SLIMMER FIGURE.

⭐ WHEN DRAWING THE LINE OF THE BODY, EITHER TRACE DIRECTLY OVER THE BLOCKING-IN OR SHIFT THE LINE TO CREATE A DIFFERENT PHYSIQUE.

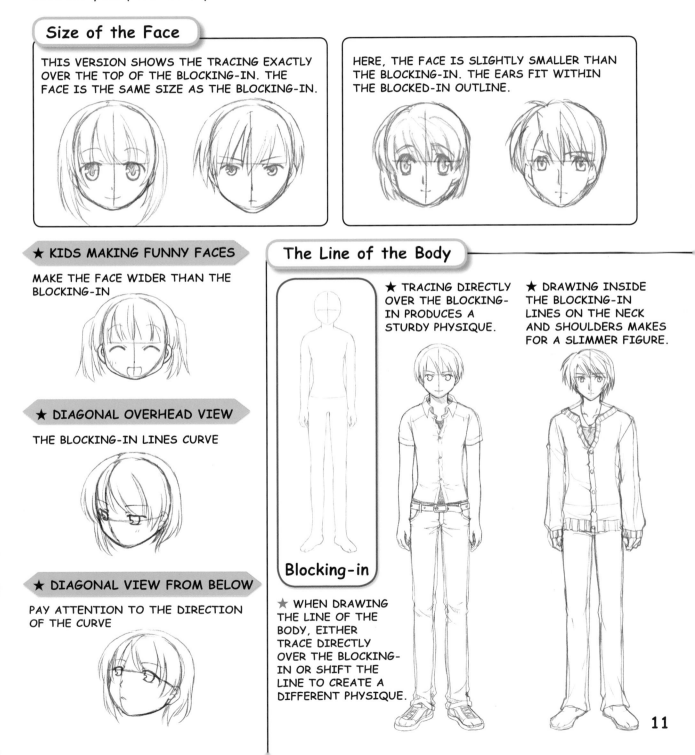

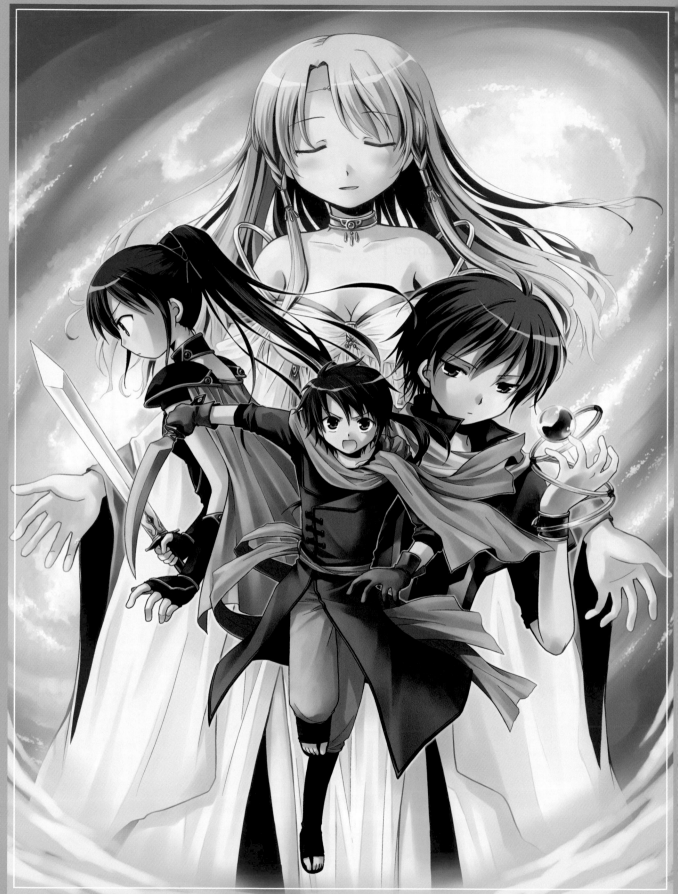

Combine various poses for a layered montage. Play with the characters' sizes, poses and placement to create a dynamic composition!

P.84 P.87 P.83 P.58

▼ **Example 2** "A PAGE OF MEMORIES" illustration: Junka Morozumi

Changing the expression on a character's face means it can be adapted to a range of different scenes and settings. Try mixing up faces and poses to use in various scenarios.

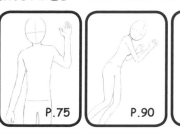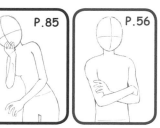

P.75 P.90 P.85 P.56

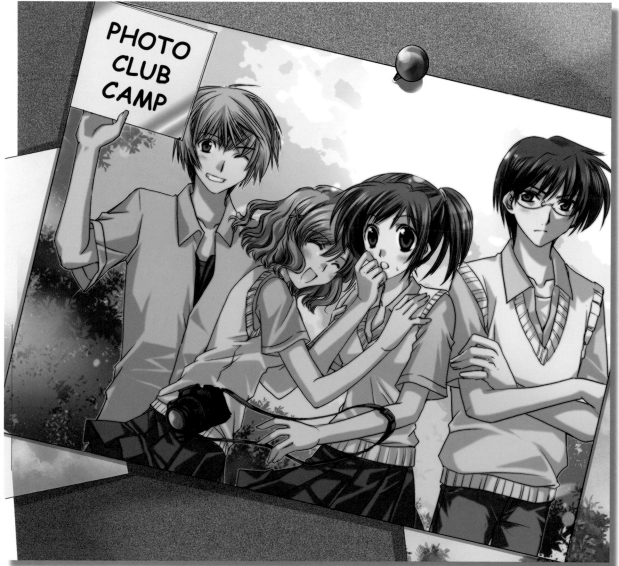

PHOTO CLUB CAMP

Example 3 **Romantic Manga: The Softer Side** Manga: Miki Kizuki

★ Combining lively expressions and poses creates a propulsive sense of drama and flow, not just in full-page scenes but in manga made up of several panels and parts.

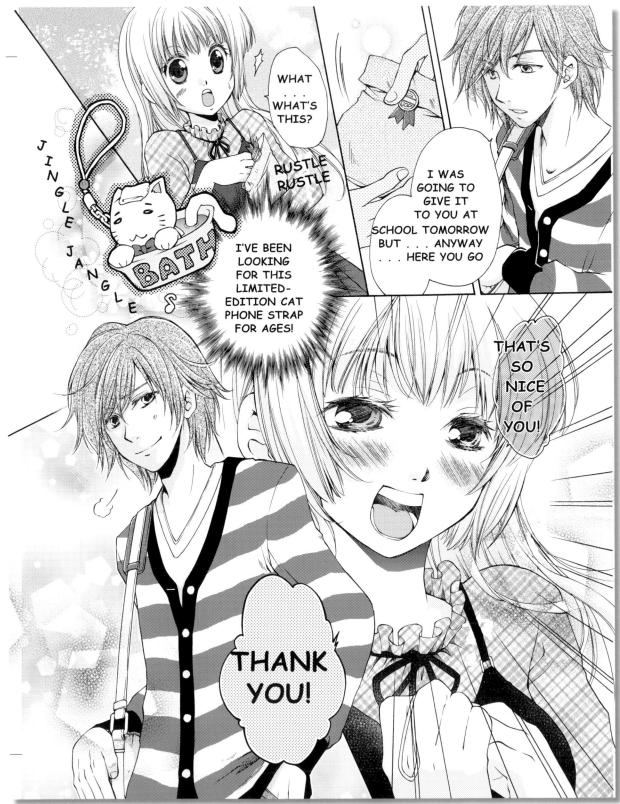

Horror and Action Manga: Finding a Harder Edge

★ The facial expression with raised eyebrows and the pose with outstretched hands perfectly capture the character's anger.

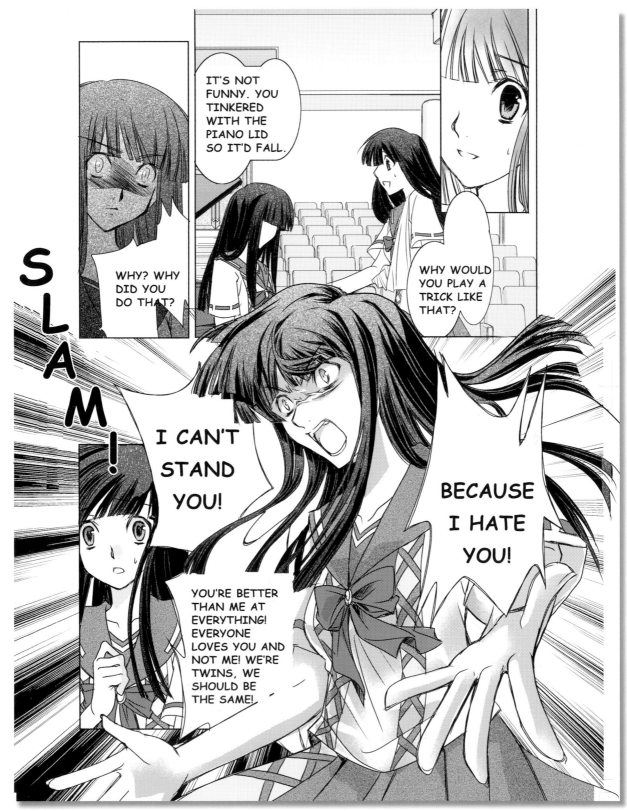

Example 4 An Infinite Variety of Styles!

★ Even when artists use the same blocking-in techniques, the drawings that result can vary widely depending on their personal style. Consider clothing, hairstyles, age and other distinguishing factors when adding complexity, subtlety and detail to your drawings.

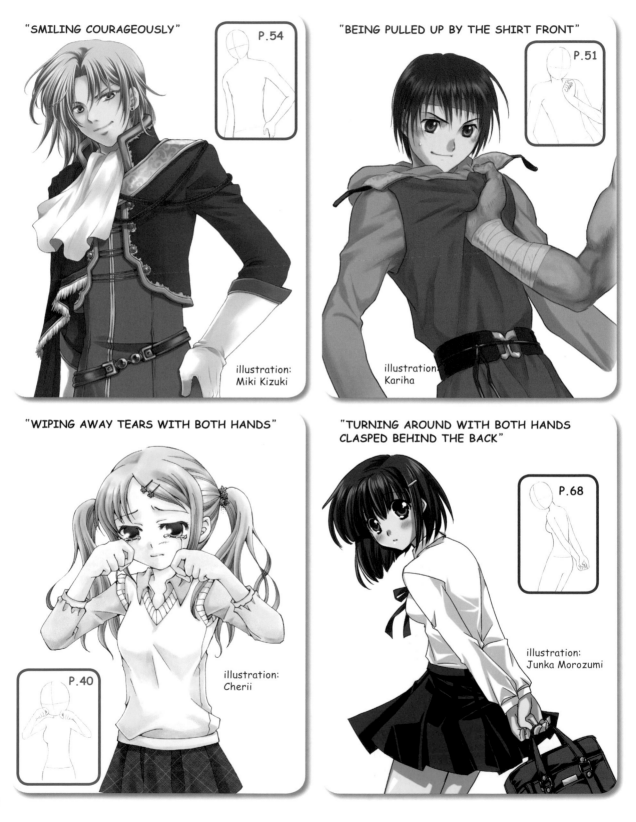

"SMILING COURAGEOUSLY"

P.54

illustration:
Miki Kizuki

"BEING PULLED UP BY THE SHIRT FRONT"

P.51

illustration:
Kariha

"WIPING AWAY TEARS WITH BOTH HANDS"

P.40

illustration:
Cherii

"TURNING AROUND WITH BOTH HANDS
CLASPED BEHIND THE BACK"

P.68

illustration:
Junka Morozumi

Creating Original Facial Expressions!

★ If three illustrators are asked to draw the same expression or mood, they'll come up with three vastly different takes on it. The drawing will reflect a particular style, the spark of originality and individual touch that makes your illustrations uniquely your own. Look at the examples below as you discover your own way of capturing the many moods of manga!

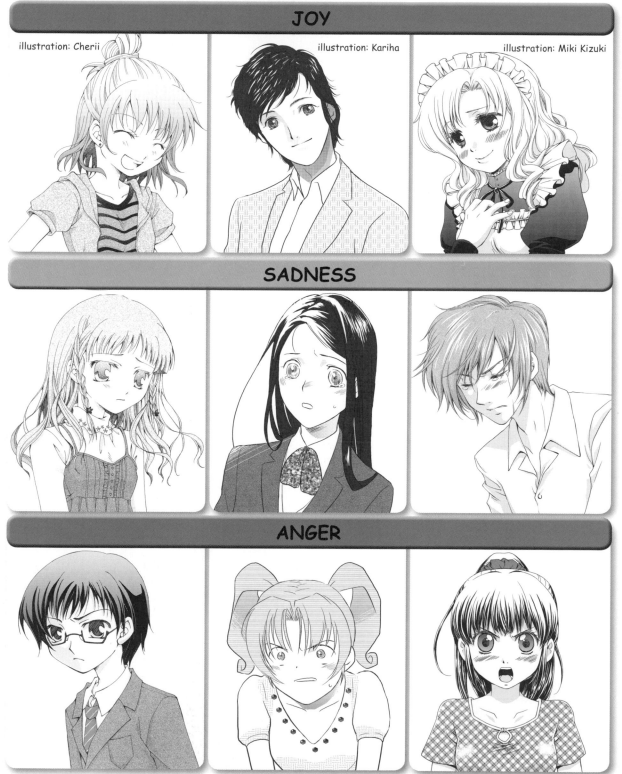

JOY

illustration: Cherii

illustration: Kariha

illustration: Miki Kizuki

SADNESS

ANGER

HOW TO USE THIS BOOK

THE IDEA IS TO PRACTICE DRAWING BY TRACING OVER THE TOPS OF THE ILLUSTRATIONS.

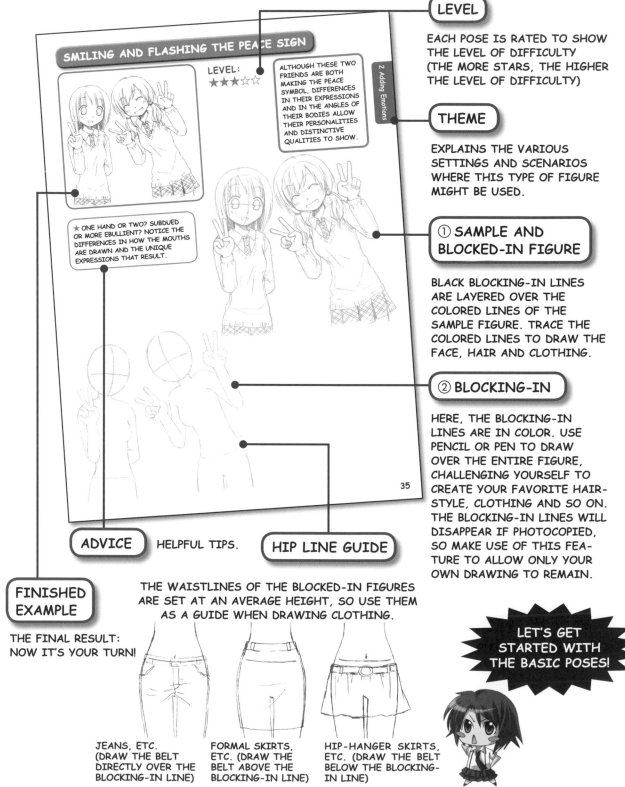

LEVEL

EACH POSE IS RATED TO SHOW THE LEVEL OF DIFFICULTY (THE MORE STARS, THE HIGHER THE LEVEL OF DIFFICULTY)

THEME

EXPLAINS THE VARIOUS SETTINGS AND SCENARIOS WHERE THIS TYPE OF FIGURE MIGHT BE USED.

① SAMPLE AND BLOCKED-IN FIGURE

BLACK BLOCKING-IN LINES ARE LAYERED OVER THE COLORED LINES OF THE SAMPLE FIGURE. TRACE THE COLORED LINES TO DRAW THE FACE, HAIR AND CLOTHING.

② BLOCKING-IN

HERE, THE BLOCKING-IN LINES ARE IN COLOR. USE PENCIL OR PEN TO DRAW OVER THE ENTIRE FIGURE, CHALLENGING YOURSELF TO CREATE YOUR FAVORITE HAIRSTYLE, CLOTHING AND SO ON. THE BLOCKING-IN LINES WILL DISAPPEAR IF PHOTOCOPIED, SO MAKE USE OF THIS FEATURE TO ALLOW ONLY YOUR OWN DRAWING TO REMAIN.

ADVICE
HELPFUL TIPS.

HIP LINE GUIDE

FINISHED EXAMPLE

THE FINAL RESULT: NOW IT'S YOUR TURN!

THE WAISTLINES OF THE BLOCKED-IN FIGURES ARE SET AT AN AVERAGE HEIGHT, SO USE THEM AS A GUIDE WHEN DRAWING CLOTHING.

LET'S GET STARTED WITH THE BASIC POSES!

JEANS, ETC. (DRAW THE BELT DIRECTLY OVER THE BLOCKING-IN LINE)

FORMAL SKIRTS, ETC. (DRAW THE BELT ABOVE THE BLOCKING-IN LINE)

HIP-HANGER SKIRTS, ETC. (DRAW THE BELT BELOW THE BLOCKING-IN LINE)

Within the illustration panel:

SMILING AND FLASHING THE PEACE SIGN

LEVEL: ★★★☆☆

ALTHOUGH THESE TWO FRIENDS ARE BOTH MAKING THE PEACE SYMBOL, DIFFERENCES IN THEIR EXPRESSIONS AND IN THE ANGLES OF THEIR BODIES ALLOW THEIR PERSONALITIES AND DISTINCTIVE QUALITIES TO SHOW.

2 Adding Emotions

★ ONE HAND OR TWO? SUBDUED OR MORE EBULLIENT? NOTICE THE DIFFERENCES IN HOW THE MOUTHS ARE DRAWN AND THE UNIQUE EXPRESSIONS THAT RESULT.

35

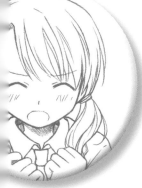
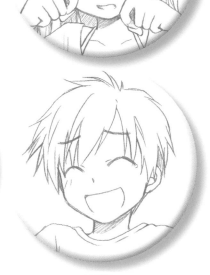
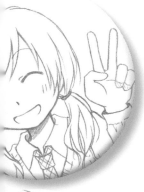

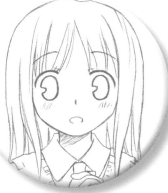

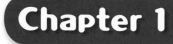 **Chapter 1**

Basic Expressions

The basic guidelines for drawing the face and its many expressions are the same for all illustrators. So it just comes down to making your drawings your own. Study and practice the expressions here, then adapt them to develop your own style.

REGULAR EXPRESSION

Pose for this Expression ▶ P.34

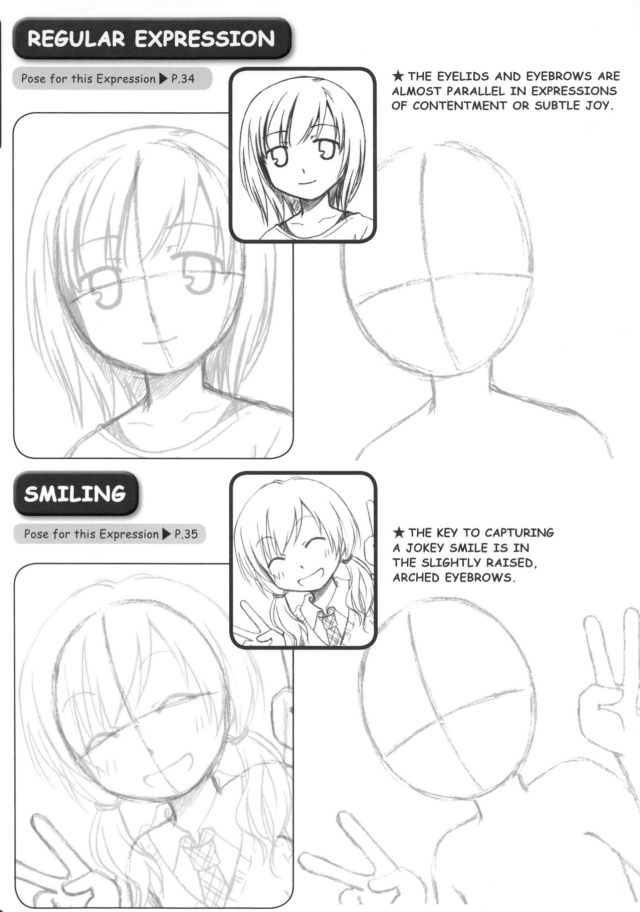

★ THE EYELIDS AND EYEBROWS ARE ALMOST PARALLEL IN EXPRESSIONS OF CONTENTMENT OR SUBTLE JOY.

SMILING

Pose for this Expression ▶ P.35

★ THE KEY TO CAPTURING A JOKEY SMILE IS IN THE SLIGHTLY RAISED, ARCHED EYEBROWS.

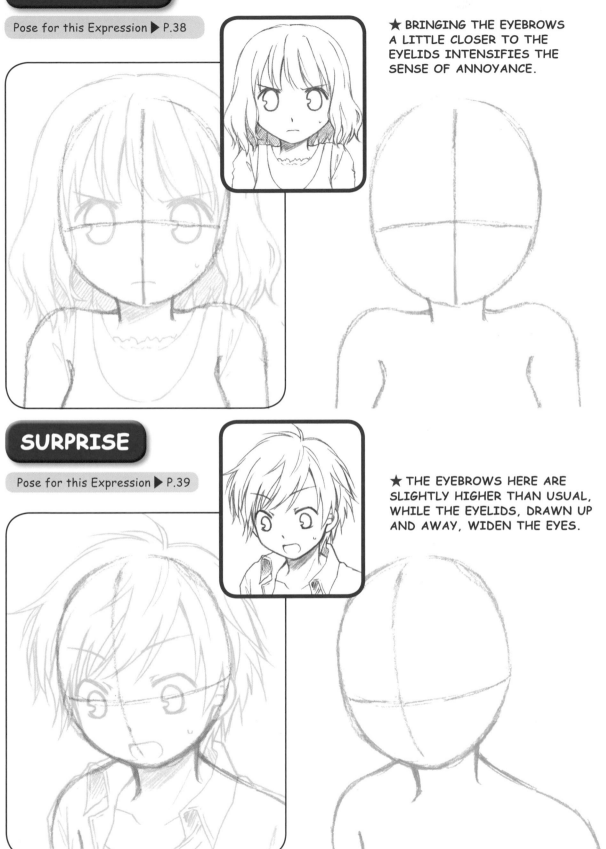

ANNOYANCE

Pose for this Expression ▶ P.38

★ BRINGING THE EYEBROWS A LITTLE CLOSER TO THE EYELIDS INTENSIFIES THE SENSE OF ANNOYANCE.

SURPRISE

Pose for this Expression ▶ P.39

★ THE EYEBROWS HERE ARE SLIGHTLY HIGHER THAN USUAL, WHILE THE EYELIDS, DRAWN UP AND AWAY, WIDEN THE EYES.

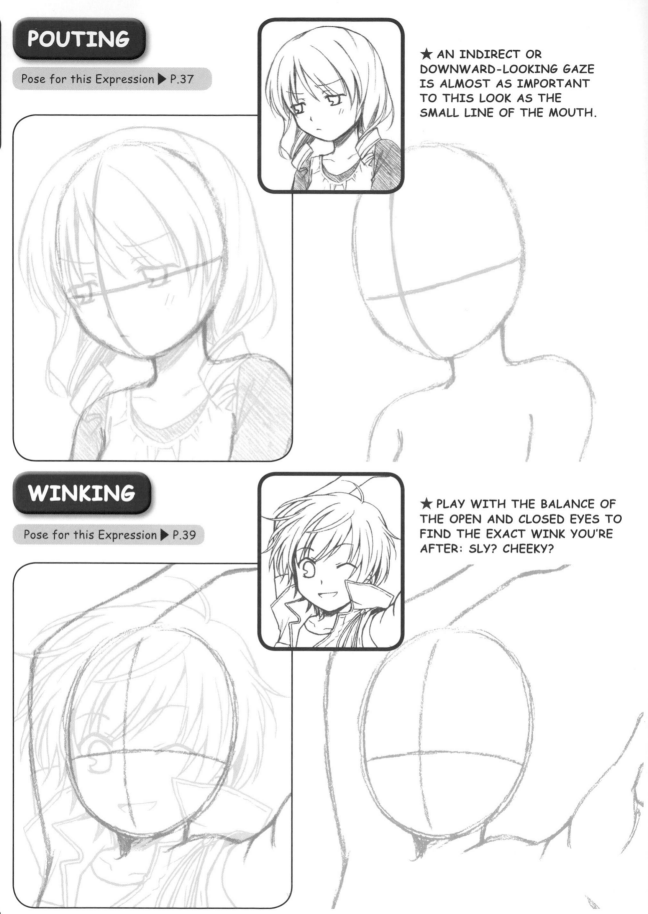

POUTING

Pose for this Expression ▶ P.37

★ AN INDIRECT OR DOWNWARD-LOOKING GAZE IS ALMOST AS IMPORTANT TO THIS LOOK AS THE SMALL LINE OF THE MOUTH.

WINKING

Pose for this Expression ▶ P.39

★ PLAY WITH THE BALANCE OF THE OPEN AND CLOSED EYES TO FIND THE EXACT WINK YOU'RE AFTER: SLY? CHEEKY?

CRYING

Pose for this Expression ▶ P.40

★ RUBBING TEARS FROM TIGHTLY CLOSED EYES IS ONE WAY TO SIGNAL SADNESS.

AMUSED

Pose for this Expression ▶ P.41

★ BROWS DRAWN UP IN A ハ SHAPE, WHEN COMBINED WITH AN OPEN MOUTH AND CLOSED EYES, SHOW A CHARACTER IN THE GRIPS OF LAUGHTER.

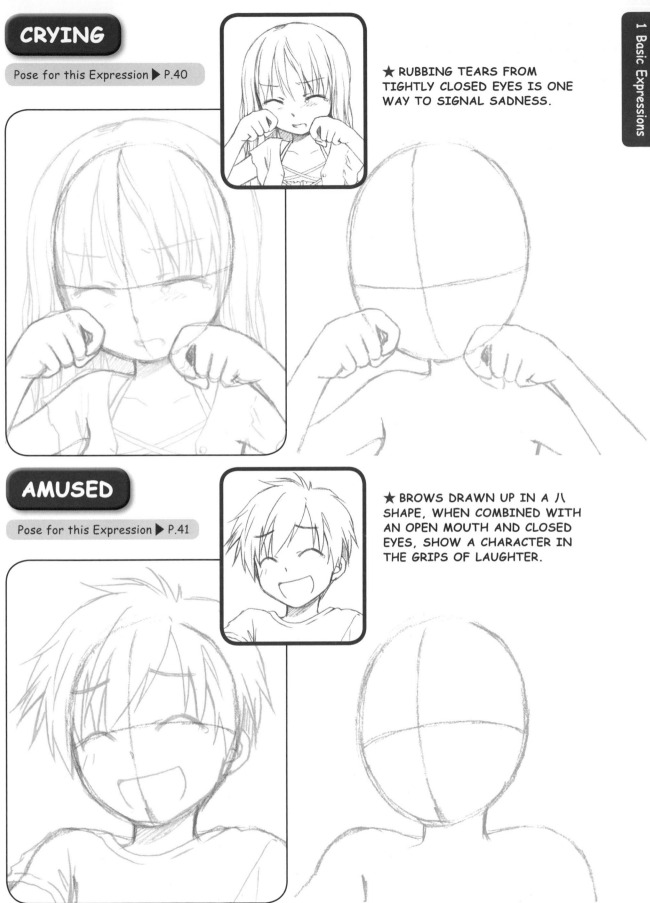

FRUSTRATION

Pose for this Expression ▶ P.44

★ LEAVE A GAP BETWEEN THE LOWER LIDS AND THE PUPILS TO HIGHLIGHT THE FIXED, FAR-OFF STARE.

LOST IN THOUGHT

Pose for this Expression ▶ P.43

★ THE FARAWAY LOOK IN THE EYES LENDS A SENSE OF DISTRACTION. PAY ATTENTION TO THE CURVE IN THE UPPER EYELIDS AS YOU DRAW.

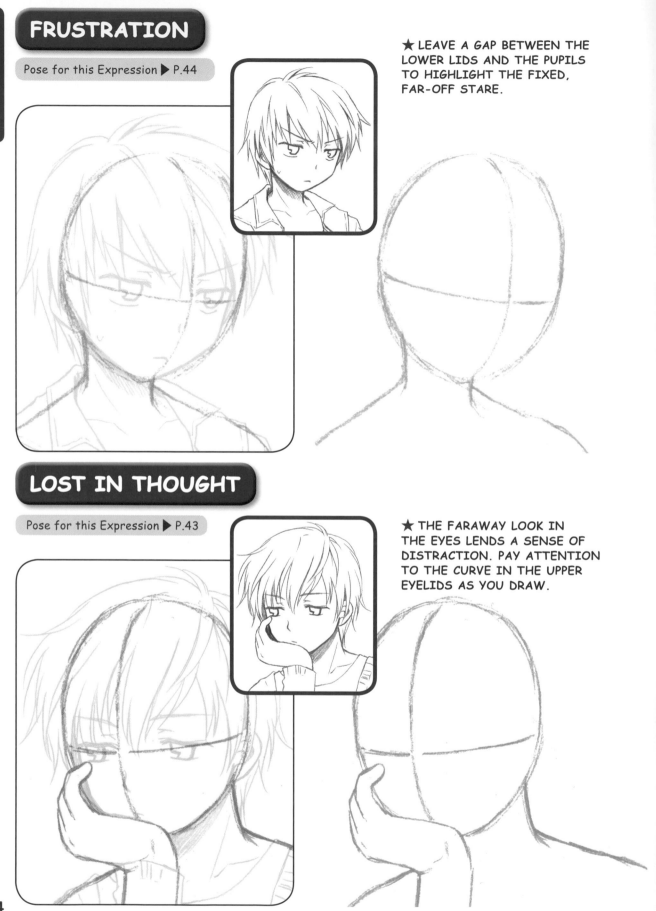

EXCITED

Pose for this Expression ▶ P.66

★ COMBINE RAISED EYEBROWS WITH A SUBTLE, POPEYED GLANCE TO CAPTURE THIS MODE OF EXPRESSION.

SMUG

Pose for this Expression ▶ P.56

★ DRAW RAISED EYEBROWS AND LIFT ONE SIDE OF THE MOUTH SLIGHTLY TO CAPTURE THIS SUBTLE REGISTER.

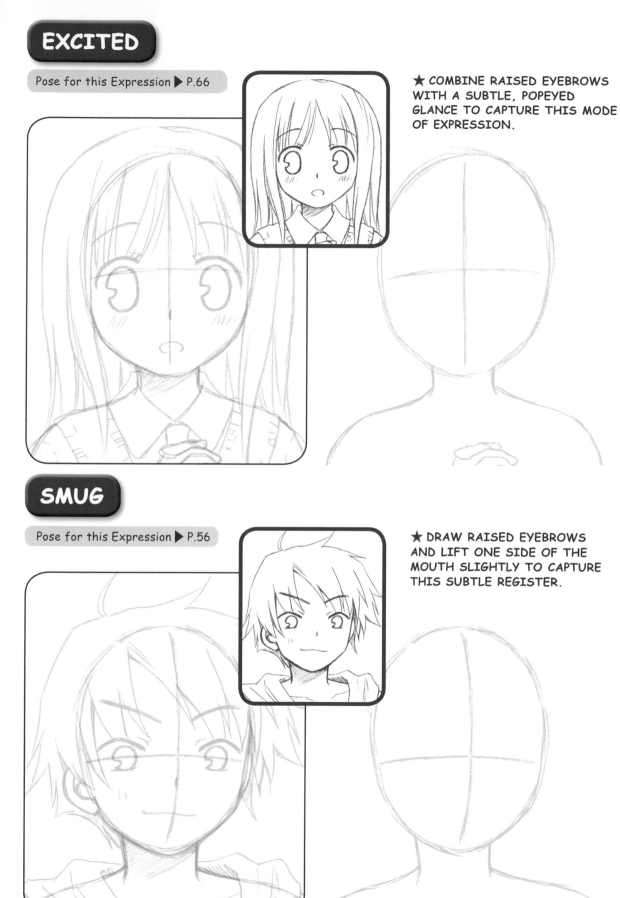

GLARING

Pose for this Expression ▶ P.51

★ FOR AN INTENSE GLARE, USE THE LINE OF THE LOWER EYELID TO ACCENTUATE THE ANGER IN THE EYES.

SNEERING

Pose for this Expression ▶ P.54

★ TO DRAW A CHARACTER LOOKING DOWN FROM ABOVE, THE LINE OF THE LOWER EYELIDS IS KEY.

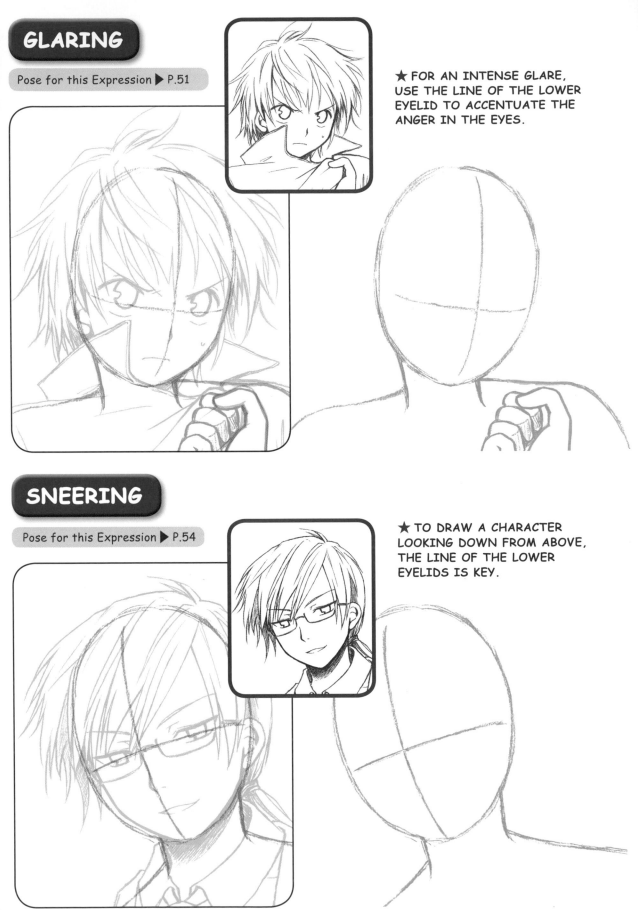

26

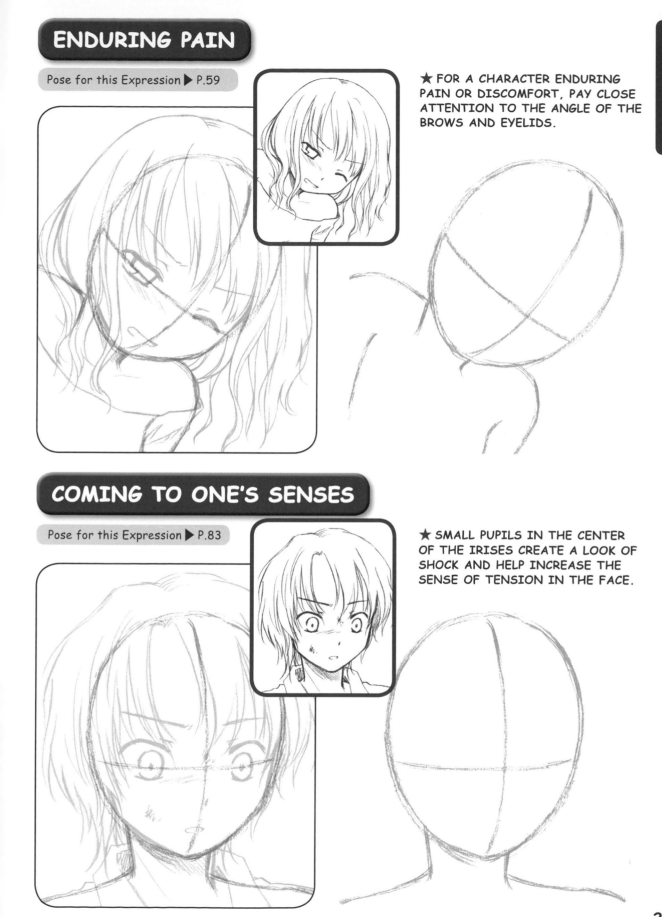

ENDURING PAIN

Pose for this Expression ▶ P.59

★ FOR A CHARACTER ENDURING PAIN OR DISCOMFORT, PAY CLOSE ATTENTION TO THE ANGLE OF THE BROWS AND EYELIDS.

COMING TO ONE'S SENSES

Pose for this Expression ▶ P.83

★ SMALL PUPILS IN THE CENTER OF THE IRISES CREATE A LOOK OF SHOCK AND HELP INCREASE THE SENSE OF TENSION IN THE FACE.

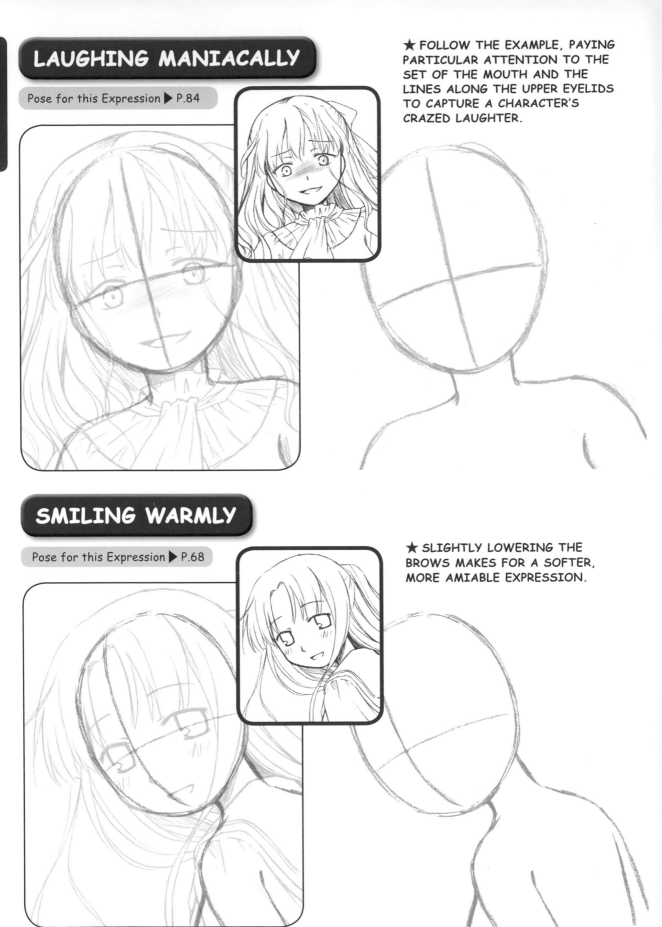

LAUGHING MANIACALLY

Pose for this Expression ▶ P.84

★ FOLLOW THE EXAMPLE, PAYING PARTICULAR ATTENTION TO THE SET OF THE MOUTH AND THE LINES ALONG THE UPPER EYELIDS TO CAPTURE A CHARACTER'S CRAZED LAUGHTER.

SMILING WARMLY

Pose for this Expression ▶ P.68

★ SLIGHTLY LOWERING THE BROWS MAKES FOR A SOFTER, MORE AMIABLE EXPRESSION.

DECLARING LOVE

Pose for this Expression ▶ P.74

★ WHEN THE EYES ARE SQUEEZED TIGHTLY SHUT, NOTICE HOW THE EYEBROWS ARE SLIGHTLY LOWER THAN USUAL.

SCREAMING

Pose for this Expression ▶ P.85

★ MAKE SURE TO OPEN THE EYES AND MOUTH WIDE. THE DIAGONAL LINE ABOVE THE NOSE HELPS INTENSIFY THE EFFECT OF THE EXPRESSION OF FRIGHT.

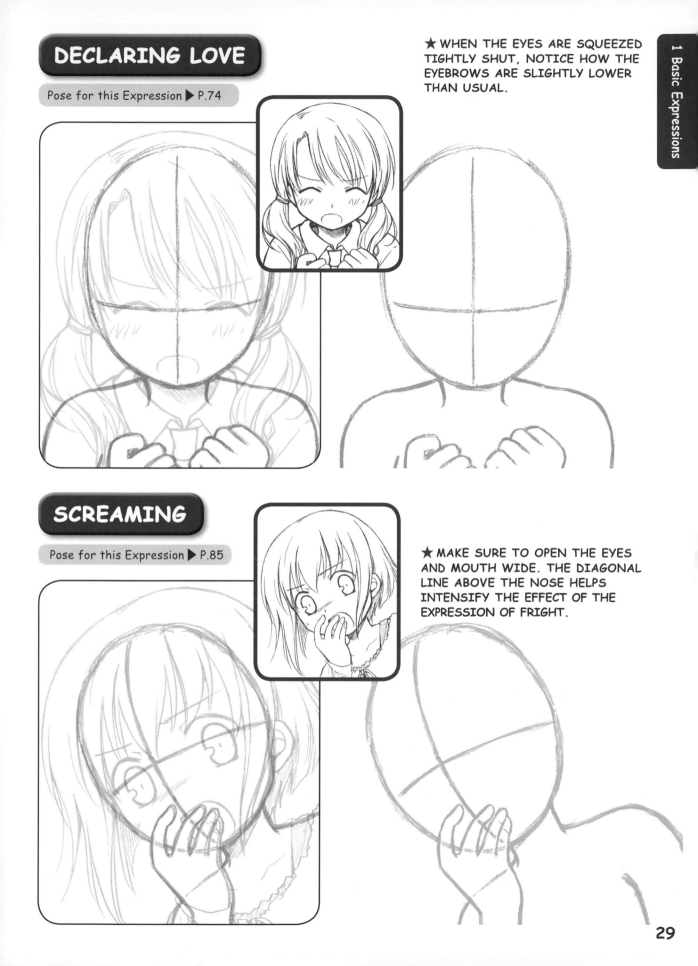

ADDING EFFECTS

★ In addition to making various facial features stand out, effects add nuance and depth to the facial expressions you're mastering.

BLUSH LINES
Blush lines appear when the character is feeling shy or awkward. See Page 64 for more examples.

EXTREMELY ANGRY

JEALOUS, POUTING

TURNING PALE
This depicts color draining from the face. Use the screen tone or slanted lines to create this look.

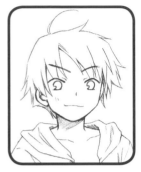

FEELING SMUG

"UH-OH!"

PANICKED SWEAT
This shows confusion or nervousness. Add this effect to the cheeks, temples and forehead.

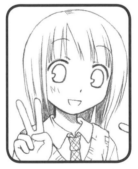

COOL AND CONTENT

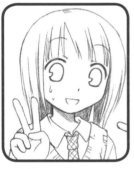

FEELING AWKWARD

SHADOW
Use this effect for a character deep in thought or mulling over a bad mood. For more on adding shadow, see Page 91.

CALM

A HINT OF SADNESS

ANGER
Veins bulging on the cheeks and temples signal an intense anger.

A WARM SMILE

CONTAINED ANGER

THREATENING
Delete the highlights from the eyes and add shadow to the center of the face.

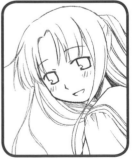

THE FLUSH OF LOVE

"I'LL NEVER FORGIVE YOU."

Adding Emotions

Chapter 2

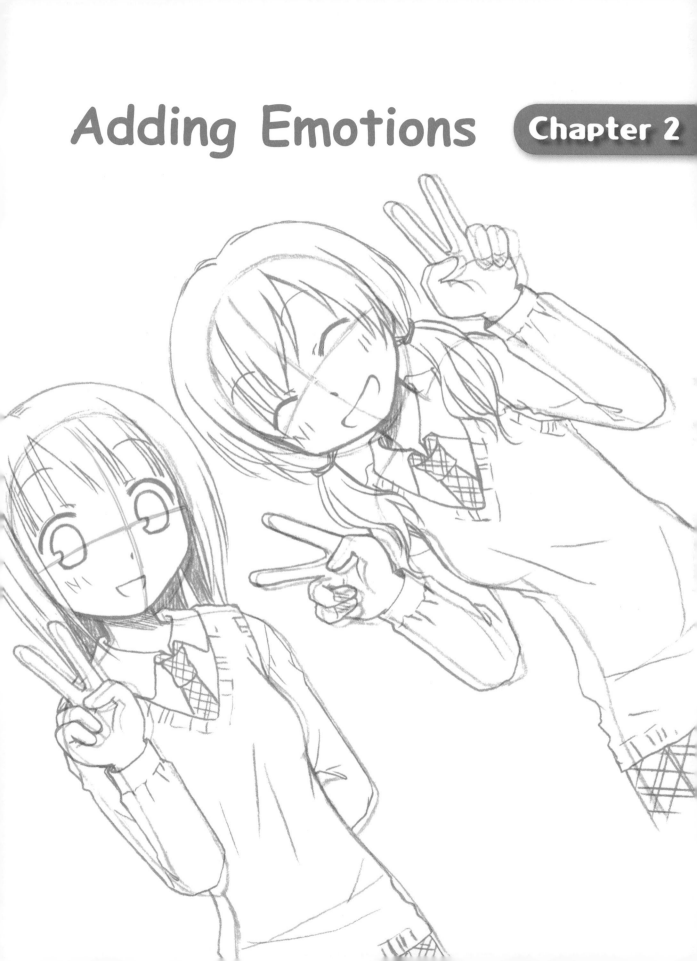

••FACE BASICS••

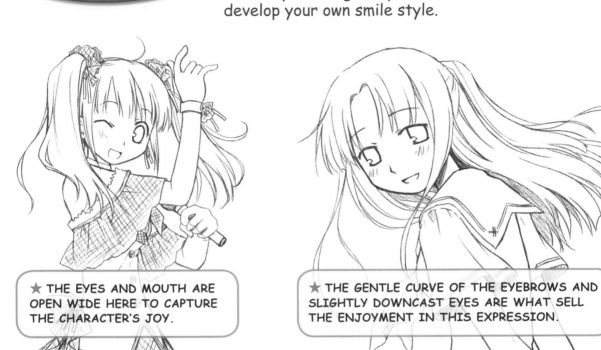

HAPPINESS/ ENJOYMENT

● There's more than one way to draw a smile: subtle differences in how the eyebrows, eyes and mouth are drawn result in a completely different look. Try altering the position of the features to develop your own smile style.

★ THE EYES AND MOUTH ARE OPEN WIDE HERE TO CAPTURE THE CHARACTER'S JOY.

★ THE GENTLE CURVE OF THE EYEBROWS AND SLIGHTLY DOWNCAST EYES ARE WHAT SELL THE ENJOYMENT IN THIS EXPRESSION.

SADNESS

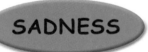

● The gaze is pointed downward and the head hung low in expressions of sadness. When the grief can't be contained, the eyes are squeezed shut as tears spill out.

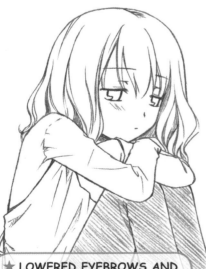

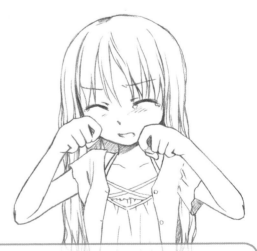

★ LOWERED EYEBROWS AND DOWNCAST EYES CONVEY AN INNER SADNESS.

★ RAISING THE SHOULDERS AND HAVING BOTH HANDS WIPING AWAY TEARS HELPS TO SOFTEN THE SEVERITY OF YOUR CHARACTER'S DISCONTENT.

RAGE

● Rage is captured in the eyebrows. When the face is pinched or tightened with emotion, the inner brows lower and draw closer to the eyes, while the outer edges lift up.

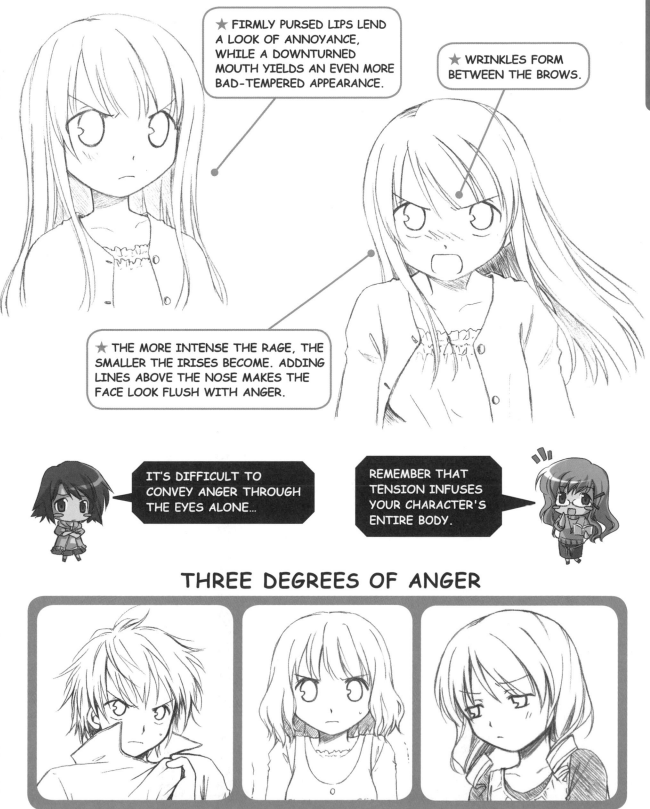

★ FIRMLY PURSED LIPS LEND A LOOK OF ANNOYANCE, WHILE A DOWNTURNED MOUTH YIELDS AN EVEN MORE BAD-TEMPERED APPEARANCE.

★ WRINKLES FORM BETWEEN THE BROWS.

★ THE MORE INTENSE THE RAGE, THE SMALLER THE IRISES BECOME. ADDING LINES ABOVE THE NOSE MAKES THE FACE LOOK FLUSH WITH ANGER.

IT'S DIFFICULT TO CONVEY ANGER THROUGH THE EYES ALONE...

REMEMBER THAT TENSION INFUSES YOUR CHARACTER'S ENTIRE BODY.

THREE DEGREES OF ANGER

STANDING STRAIGHT

LEVEL:

START WITH A STANDING FIGURE, MAKING CHANGES AND REFINEMENTS TO THE FACIAL EXPRESSION AS YOU GO ALONG.

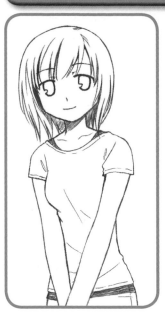

★ NORMALLY THE EXPRESSION IS NEUTRAL, BUT RAISING THE CORNERS OF THE MOUTH GIVES THE APPEARANCE OF A FAINT SMILE.

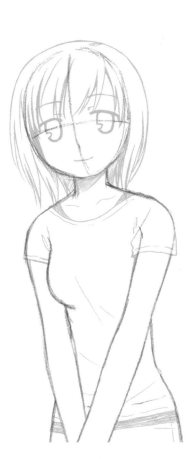

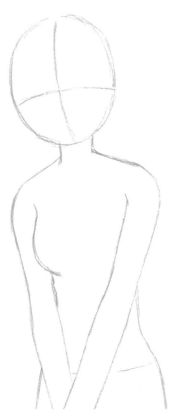

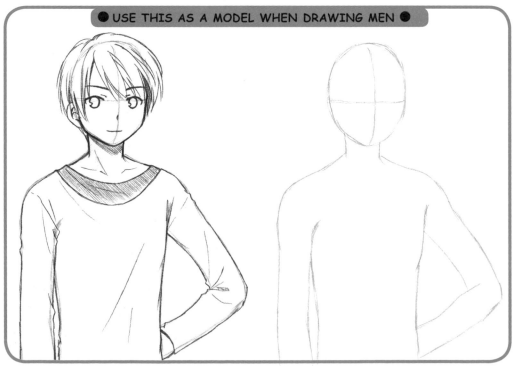

● USE THIS AS A MODEL WHEN DRAWING MEN ●

SMILING AND FLASHING THE PEACE SIGN

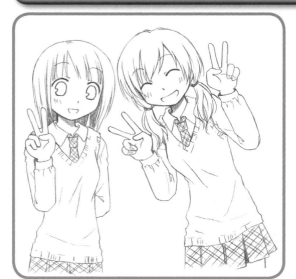

LEVEL:
★★★☆☆

ALTHOUGH THESE TWO FRIENDS ARE BOTH MAKING THE PEACE SYMBOL, DIFFERENCES IN THEIR EXPRESSIONS AND IN THE ANGLES OF THEIR BODIES ALLOW THEIR PERSONALITIES AND DISTINCTIVE QUALITIES TO SHOW.

★ ONE HAND OR TWO? SUBDUED OR MORE EBULLIENT? NOTICE THE DIFFERENCES IN HOW THE MOUTHS ARE DRAWN AND THE UNIQUE EXPRESSIONS THAT RESULT.

EXPRESSING SURPRISE

LEVEL: ★★☆☆☆

THE FIGURE APPEARS TO BE PULLING BACK, AS IF STARTLED. NOTE ALSO THAT THE BODY IS SEEN FROM A SLIGHT ANGLE AND THE SHOULDERS ARE RAISED.

★ WHEN THE EYES ARE OPEN WIDE, A GAP FORMS BETWEEN THE UPPER EYELIDS AND THE IRISES.

● REFER TO THESE WHEN DRAWING WOMEN ●

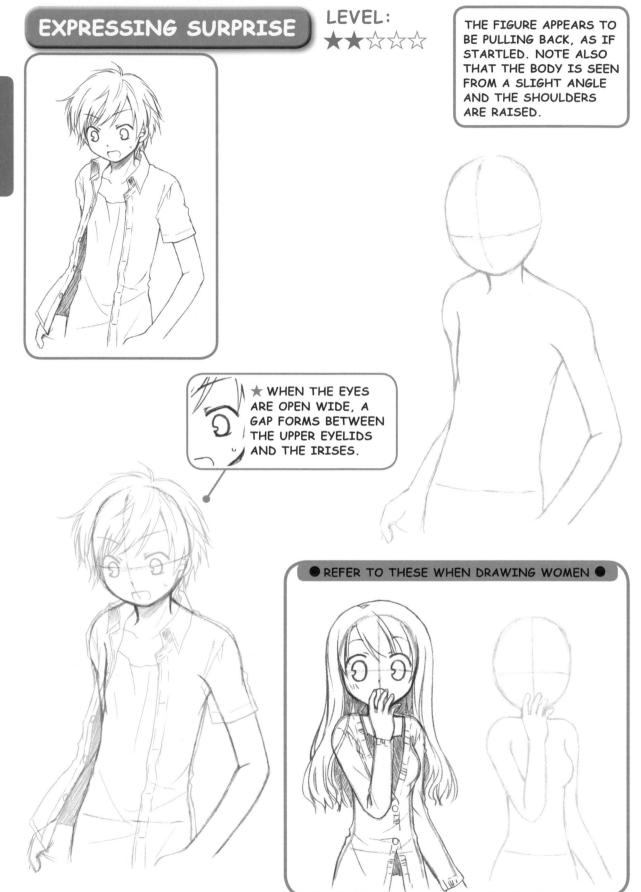

POUTING WITH FOLDED ARMS

LEVEL:
★★★☆☆

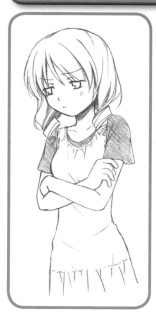

THIS CROSS-ARMED POSE CAN BE VARIED TO CONVEY DIFFERENT DEGREES OF JEALOUSY OR SULKING.

★ MAKING THE UPPER EYELIDS STRAIGHTER AND SLIGHTLY SUNKEN HIGHLIGHTS THE CHARACTER'S DOWNCAST EXPRESSION.

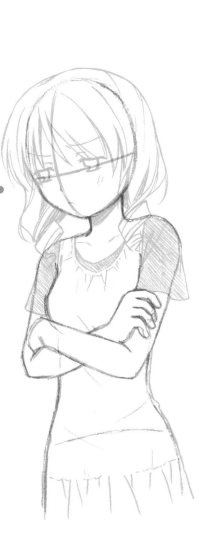

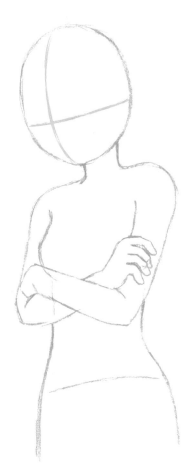

FISTS CLENCHED IN RAGE

LEVEL: ★★★☆☆

THIS POSE SHOWS THE HANDS SHAKING WITH RAGE. A WIDE-OPEN MOUTH GIVES THE APPEARANCE OF SCREAMING.

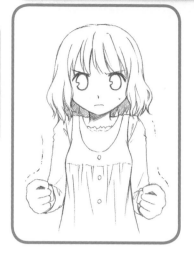

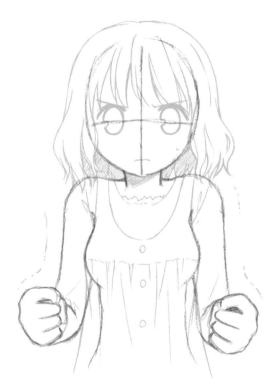

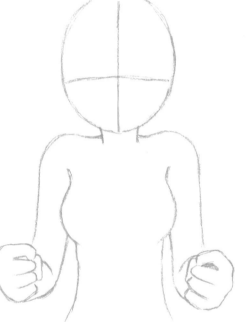

★ KEY TO EXPRESSIONS OF RAGE ARE THE RAISED SHOULDERS AND PROMINENTLY RAISED EYEBROWS. ADDING DROPS OF SWEAT INTENSIFIES THE LOOK.

JUMPING FOR JOY

LEVEL: ★★★★★

WHEN A CHARACTER IS LEAPING IN VICTORY, THE OUTSTRETCHED HAND ENHANCES THE SENSE OF JOYFUL ABANDON.

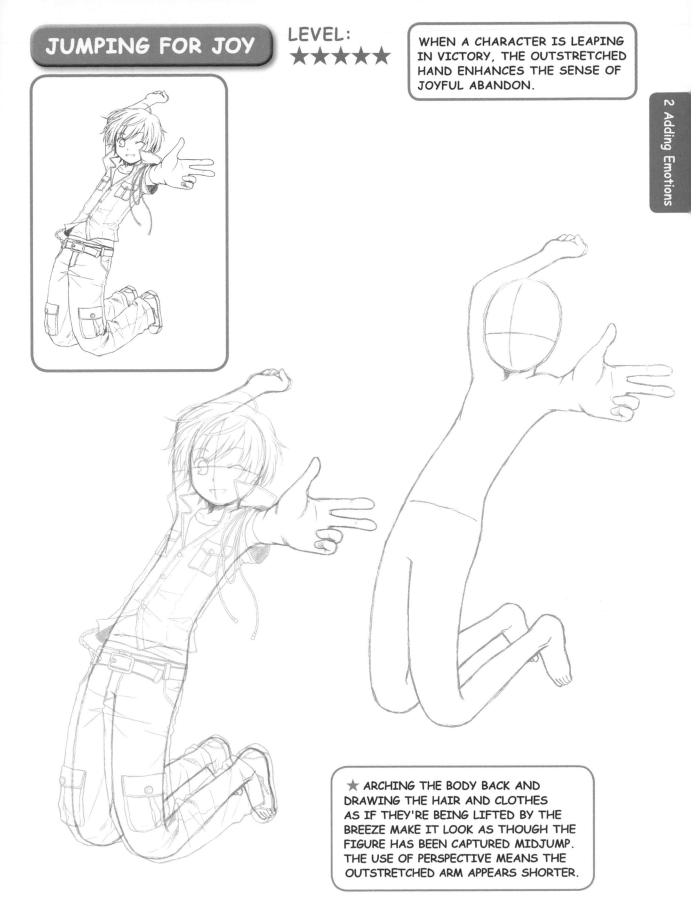

★ ARCHING THE BODY BACK AND DRAWING THE HAIR AND CLOTHES AS IF THEY'RE BEING LIFTED BY THE BREEZE MAKE IT LOOK AS THOUGH THE FIGURE HAS BEEN CAPTURED MIDJUMP. THE USE OF PERSPECTIVE MEANS THE OUTSTRETCHED ARM APPEARS SHORTER.

WIPING TEARS AWAY

LEVEL: ★★☆☆☆

DRAWING THE FACE LOOKING SLIGHTLY DOWN IS THE FIRST STEP IN CONVEYING A CHARACTER'S SADNESS.

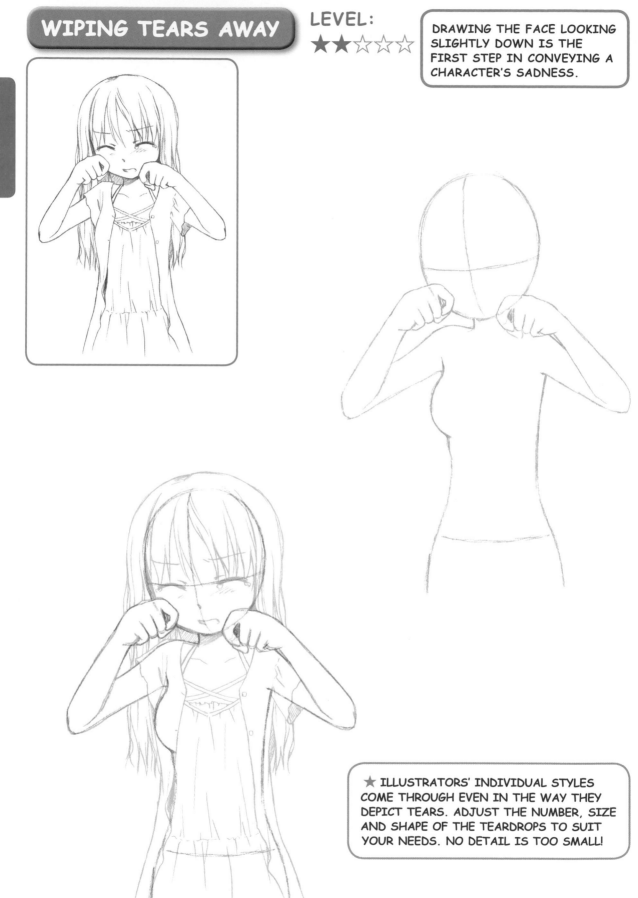

★ ILLUSTRATORS' INDIVIDUAL STYLES COME THROUGH EVEN IN THE WAY THEY DEPICT TEARS. ADJUST THE NUMBER, SIZE AND SHAPE OF THE TEARDROPS TO SUIT YOUR NEEDS. NO DETAIL IS TOO SMALL!

POINTING AND LAUGHING HEARTILY

LEVEL:
★★★★☆

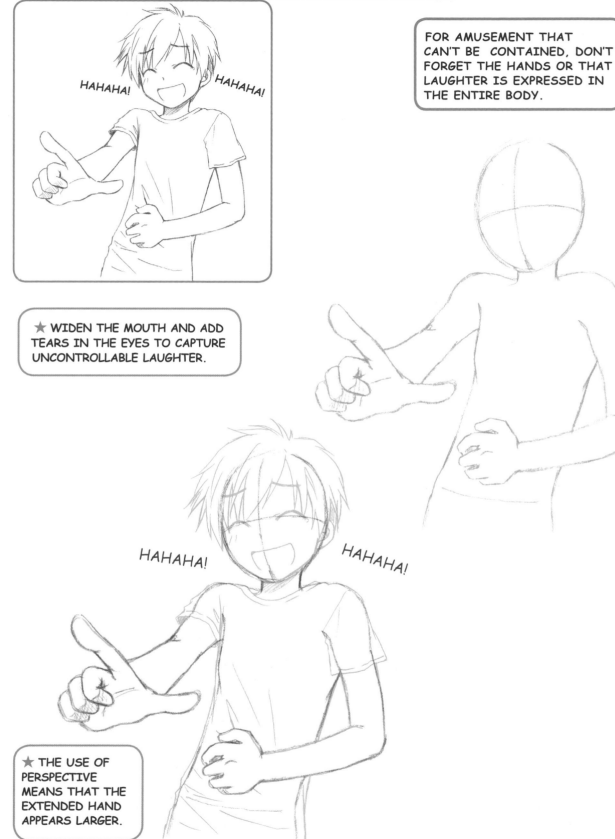

HAHAHA!

HAHAHA!

FOR AMUSEMENT THAT CAN'T BE CONTAINED, DON'T FORGET THE HANDS OR THAT LAUGHTER IS EXPRESSED IN THE ENTIRE BODY.

★ WIDEN THE MOUTH AND ADD TEARS IN THE EYES TO CAPTURE UNCONTROLLABLE LAUGHTER.

HAHAHA!

HAHAHA!

★ THE USE OF PERSPECTIVE MEANS THAT THE EXTENDED HAND APPEARS LARGER.

HOLDING ONESELF

LEVEL:
★★★☆☆

BOTH THE BODY AND THE FACE CONVEY THE CHARACTER'S LONELINESS AND SORROW. BACKGROUND SCENERY CAN BE ADDED TO HEIGHTEN THE SENSE THAT THE SOLITARY FIGURE APPEARS TO BE COLD.

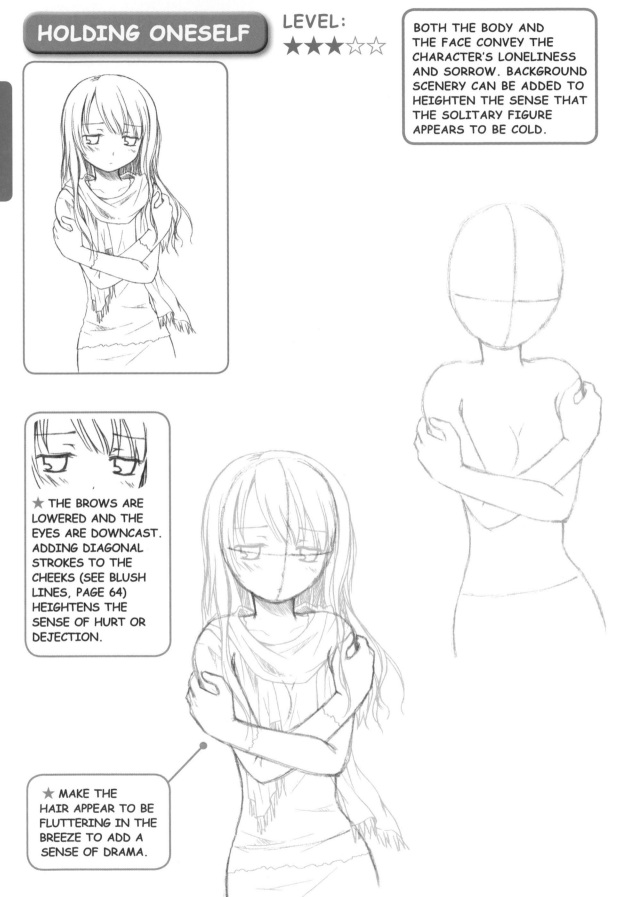

★ THE BROWS ARE LOWERED AND THE EYES ARE DOWNCAST. ADDING DIAGONAL STROKES TO THE CHEEKS (SEE BLUSH LINES, PAGE 64) HEIGHTENS THE SENSE OF HURT OR DEJECTION.

★ MAKE THE HAIR APPEAR TO BE FLUTTERING IN THE BREEZE TO ADD A SENSE OF DRAMA.

RESTING A CHEEK ON ONE'S HAND

LEVEL:
★★★☆☆

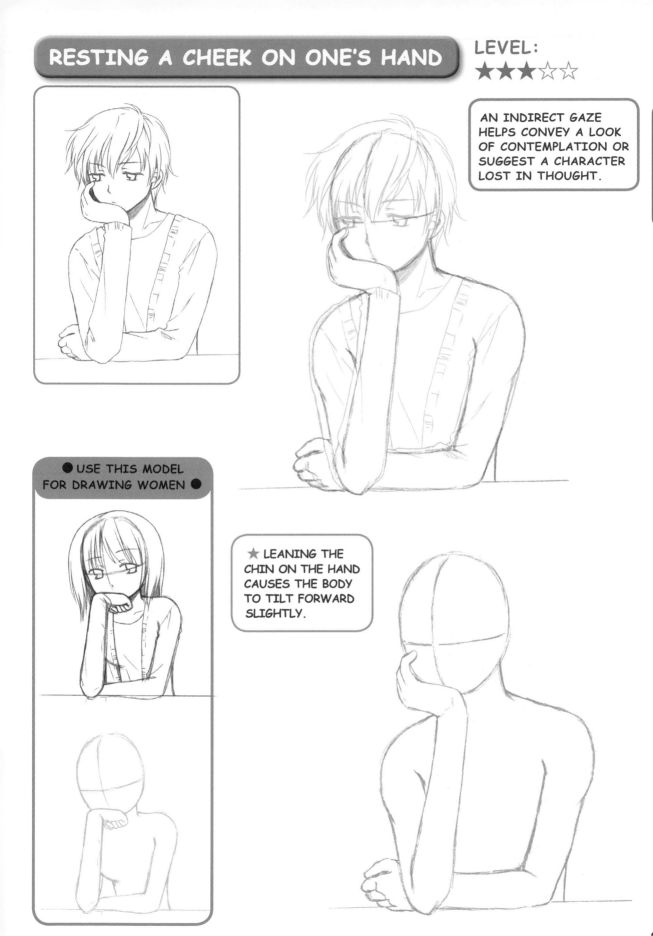

AN INDIRECT GAZE HELPS CONVEY A LOOK OF CONTEMPLATION OR SUGGEST A CHARACTER LOST IN THOUGHT.

● USE THIS MODEL FOR DRAWING WOMEN ●

★ LEANING THE CHIN ON THE HAND CAUSES THE BODY TO TILT FORWARD SLIGHTLY.

GETTING IN A HUFF

LEVEL: ★★★★☆

TYPICALLY EXPRESSING ANNOYANCE, THIS POSE CAN BE TRANSFORMED INTO ONE OF PRIDE IF THE FACIAL EXPRESSION IS CHANGED TO A SMUG SMILE.

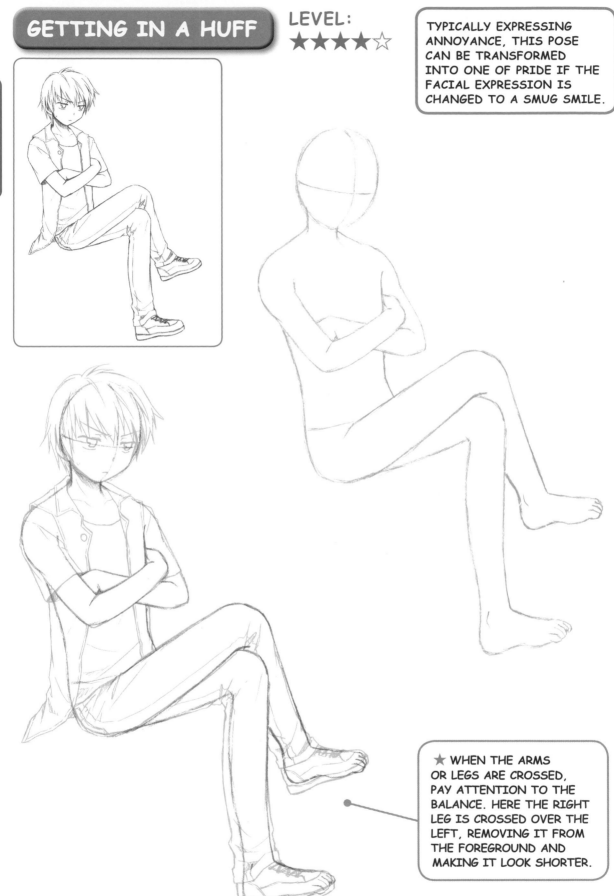

★ WHEN THE ARMS OR LEGS ARE CROSSED, PAY ATTENTION TO THE BALANCE. HERE THE RIGHT LEG IS CROSSED OVER THE LEFT, REMOVING IT FROM THE FOREGROUND AND MAKING IT LOOK SHORTER.

FEELING DEPRESSED

LEVEL:
★★★★☆

TRY POSITIONING A LONELY OR SOLITARY FIGURE IN THE CORNER OF A ROOM OR ON A BED.

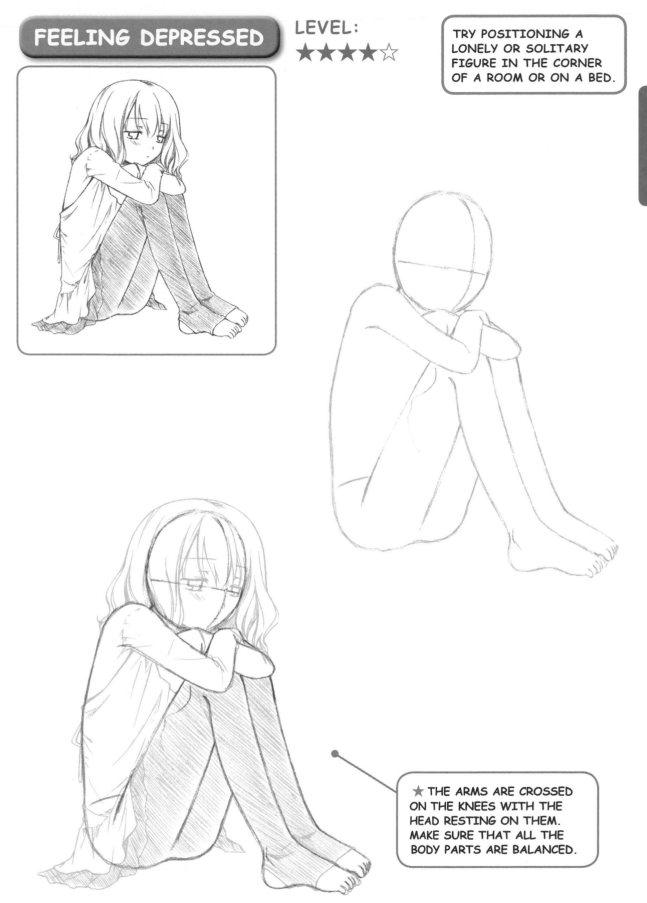

★ THE ARMS ARE CROSSED ON THE KNEES WITH THE HEAD RESTING ON THEM. MAKE SURE THAT ALL THE BODY PARTS ARE BALANCED.

SINGING AND DANCING

LEVEL:
★★★☆☆

THIS POSE MIMICS A PERFORMER ONSTAGE HOLDING A MICROPHONE. ADD A BUBBLY SMILE AND ENERGETIC DANCE MOVEMENTS TO HEIGHTEN THE SENSE OF JOYFUL ABANDON.

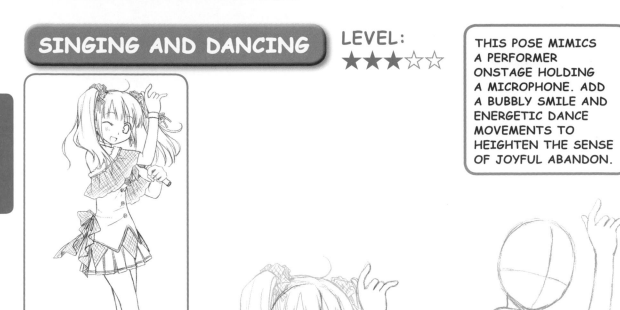

★ LAYERS OF VARIOUS FABRICS ADD A SENSE OF MOVEMENT TO THE COMPOSITION. DON'T FORGET TO ADD DETAIL TO THE SOCKS, FOOTWEAR AND ACCESSORIES.

FALLING DOWN IN DESPAIR

LEVEL:
★★★★★

USE THIS POSE FOR INTENSE SHOCK OR REGRET IT'S HARD TO RECOVER FROM.

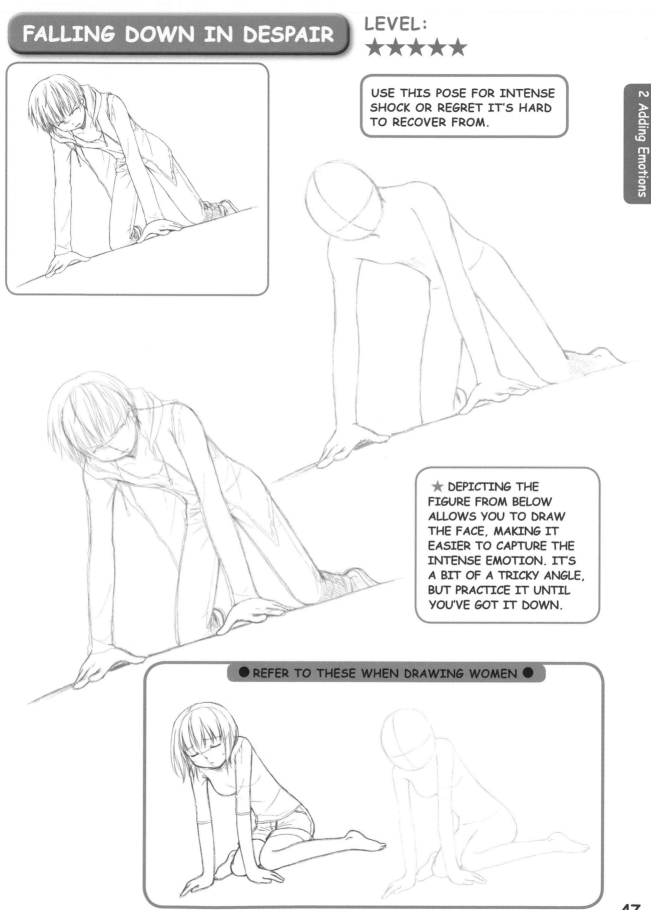

★ DEPICTING THE FIGURE FROM BELOW ALLOWS YOU TO DRAW THE FACE, MAKING IT EASIER TO CAPTURE THE INTENSE EMOTION. IT'S A BIT OF A TRICKY ANGLE, BUT PRACTICE IT UNTIL YOU'VE GOT IT DOWN.

● REFER TO THESE WHEN DRAWING WOMEN ●

47

SEASONAL TOUCHES

★ Working the seasons into your scenes allows for a greater range of facial expressions. Using these examples as starting points, try drawing various pictures with seasonal touches.

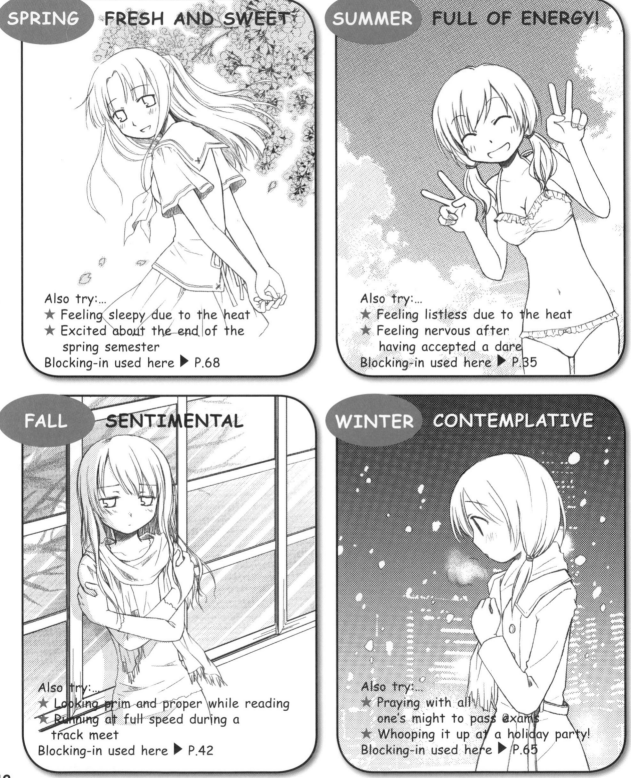

SPRING FRESH AND SWEET

Also try:...
★ Feeling sleepy due to the heat
★ Excited about the end of the spring semester
Blocking-in used here ▶ P.68

SUMMER FULL OF ENERGY!

Also try:...
★ Feeling listless due to the heat
★ Feeling nervous after having accepted a dare
Blocking-in used here ▶ P.35

FALL SENTIMENTAL

Also try:...
★ Looking prim and proper while reading
★ Running at full speed during a track meet
Blocking-in used here ▶ P.42

WINTER CONTEMPLATIVE

Also try:...
★ Praying with all one's might to pass exams
★ Whooping it up at a holiday party!
Blocking-in used here ▶ P.65

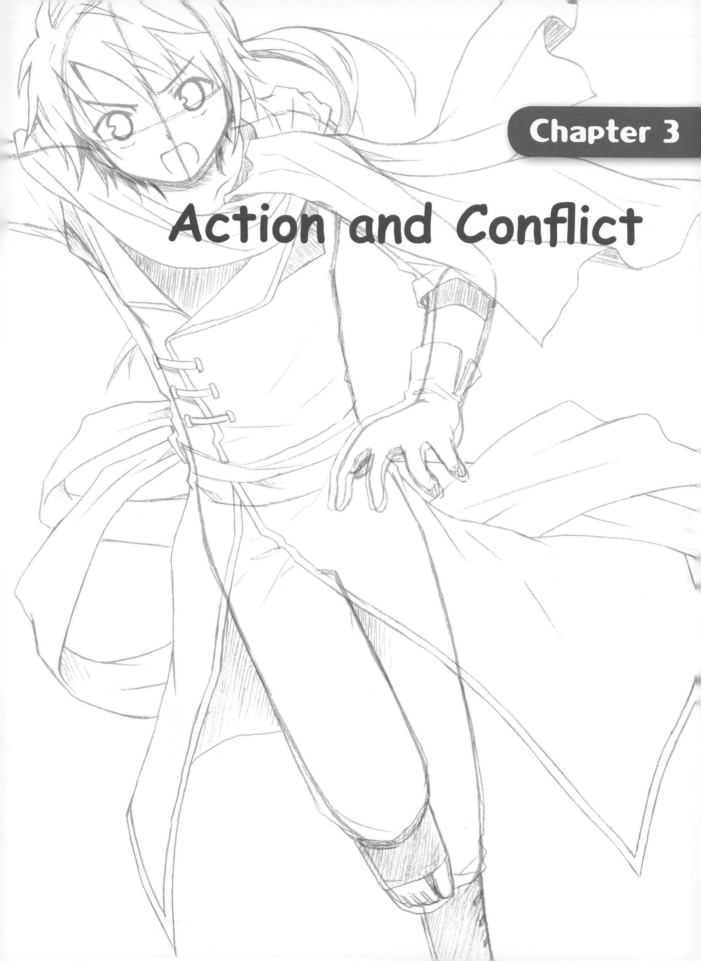

Chapter 3

Action and Conflict

EXPRESSIONS FOR ★★ FIGHT SCENES ★★

★ In scenes involving fighting or conflict, expressions become intense and serious. When facing opponents, the gaze is fixed steadily on them at all times. Aim for a dynamic, unusual pose when drawing the body, in order to ratchet up the tension in the scene.

★ THE STRENGTH OF AN UNWAVERING GLARE AT AN OPPONENT INTENSIFIES A CHARACTER'S PRESENCE. AIM FOR A LOOK SO PIERCING THAT IT SEEMS AS IF THE CHARACTER IS GLARING OUT FROM THE PAGE.

★ MAKE THE CLOTHES AND HAIR DISHEVELED TO GIVE THE SENSE OF A VIOLENT FIGHT.

★ TO SHOW A CHARACTER'S VULNERABILITY, DRAW THE ARM RAISED IN AN ATTEMPT TO COVER THE BODY. THE FACIAL EXPRESSION SHOWS THE DEEP UNEASE AT BEING DRAWN INTO A CONFLICT.

CAN I SHOW THE WHOLE FIGHT FROM BEGINNING TO END ON ONE SHEET OF PAPER?

DRAWING A CHARACTER LOOKING AT AN OPPONENT WITH FRUSTRATED, UPTURNED EYES CONVEYS A DETERMINATION TO WIN, DESPITE BEING A LESS ACCOMPLISHED FIGHTER. OR DRAWING THE WINNER LOOKING DOWN ON THE LOSER CONVEYS A SENSE OF SUPERIORITY.

BEING GRABBED BY THE SHIRT FRONT

THIS IS THE KIND OF TENSE SCENE THAT REALLY GRABS YOUR ATTENTION AND GETS YOUR PULSE POUNDING. USE IT FOR REALISTIC OR FANTASY STORIES ALIKE.

★ KEEP IN MIND WHEN DRAWING THE SHIRT THAT THE COLLAR IS BEING FORCIBLY TUGGED.

WINCING IN PAIN

LEVEL: ★★☆☆☆

EVEN THOUGH HIS SHOULDER HAS BEEN INJURED IN BATTLE, THIS CHARACTER HAS NO INTENTION OF GIVING UP.

★ DRAW THE SHOULDER SO THAT IT STARTS BEHIND THE NECK. THAT WAY, THE FIGURE APPEARS TO BE LEANING FORWARD IN PAIN.

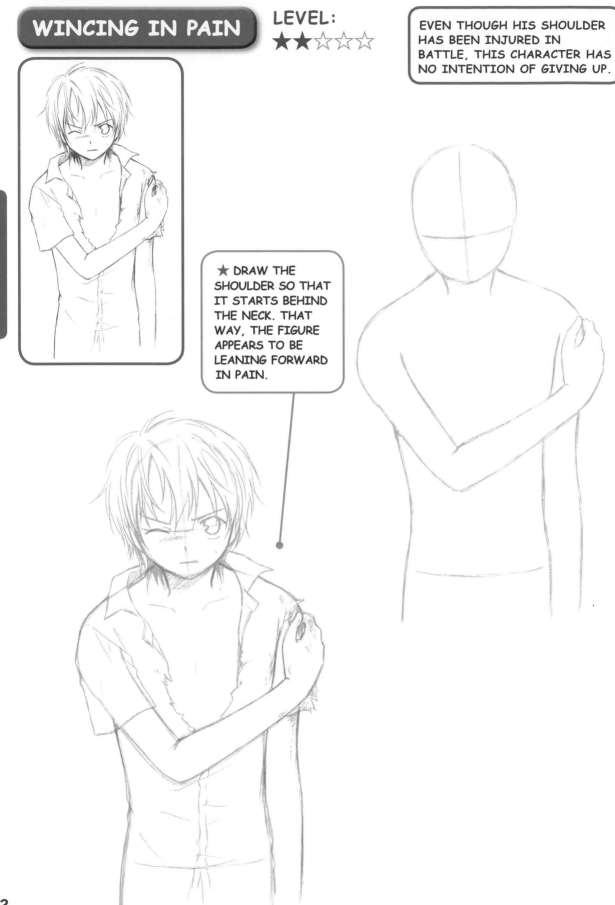

RAISING AN ARM IN SELF-DEFENCE

LEVEL:

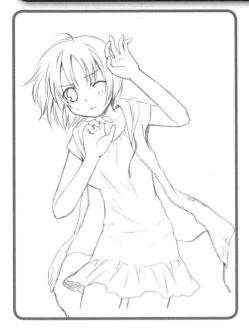

SHE TRIES TO AVOID THE IMPACT BY RAISING HER ARM.

★ THE EYE CLOSEST TO THE APPROACHING BLOW CLOSES UNCONSCIOUSLY. AS THIS POSE IS WHOLLY REACTIVE, THERE'S NO TIME FOR THE HANDS TO CLENCH INTO FISTS.

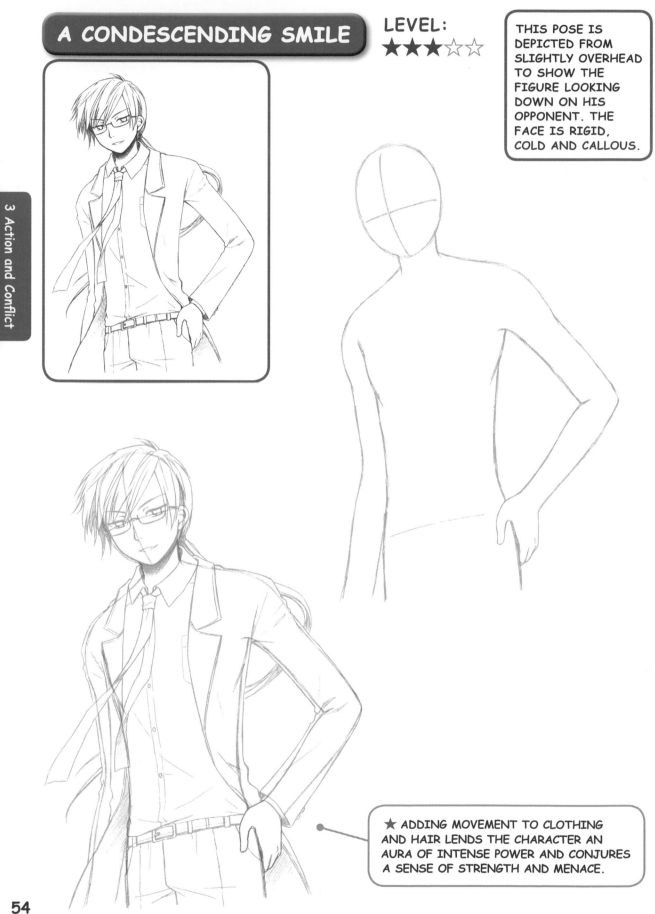

A CONDESCENDING SMILE

LEVEL:
★★★☆☆

THIS POSE IS DEPICTED FROM SLIGHTLY OVERHEAD TO SHOW THE FIGURE LOOKING DOWN ON HIS OPPONENT. THE FACE IS RIGID, COLD AND CALLOUS.

★ ADDING MOVEMENT TO CLOTHING AND HAIR LENDS THE CHARACTER AN AURA OF INTENSE POWER AND CONJURES A SENSE OF STRENGTH AND MENACE.

POINTING A DAGGER

LEVEL:
★★☆☆☆

HERE, A YOUNG GIRL DESPERATELY FIGHTS AN OPPONENT, SHOWN NOT JUST IN HER POSE BUT IN HER EXPRESSION OF FEAR AND ALARM.

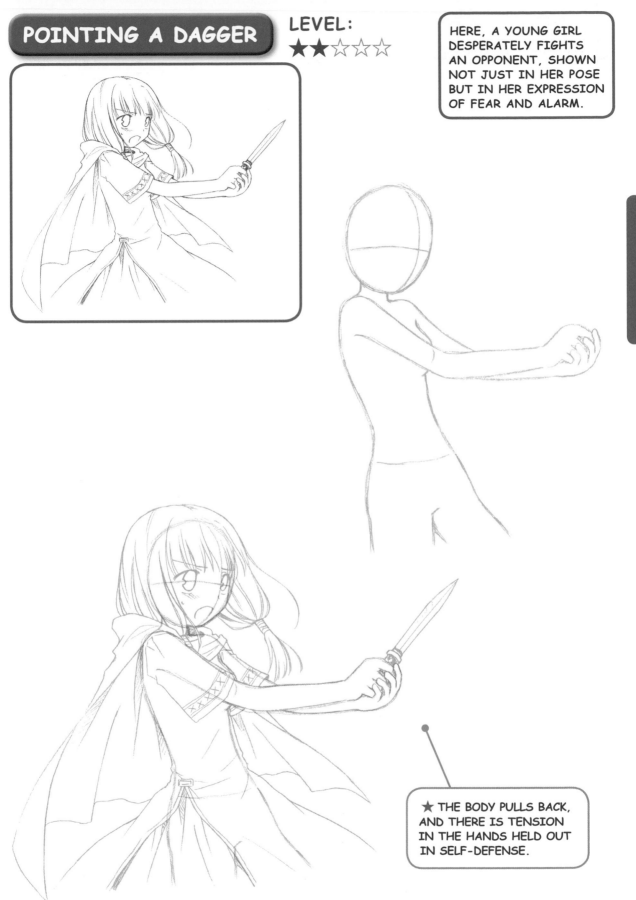

★ THE BODY PULLS BACK, AND THERE IS TENSION IN THE HANDS HELD OUT IN SELF-DEFENSE.

SMUGLY FOLDING THE ARMS

LEVEL:
★★★☆☆

"YOU'RE IN TROUBLE NOW!" HERE THE BODY ARCHES SLIGHTLY BACK, AND THE HANDS ARE FOLDED IN FRONT.

★ THE EXPRESSION IS TEASING AND PROUD. THE WAY THE EYEBROWS ARE RAISED AND THE SET OF THE GRIN ARE THE MOST IMPORTANT ELEMENTS TO MASTER.

STANDING ONE'S GROUND

LEVEL:
★★★☆☆

"I'LL NEVER FORGIVE YOU!" THIS POSE CAPTURES A FIGHTING SPIRIT FUELED BY FRUSTRATION AND A SENSE OF INJUSTICE.

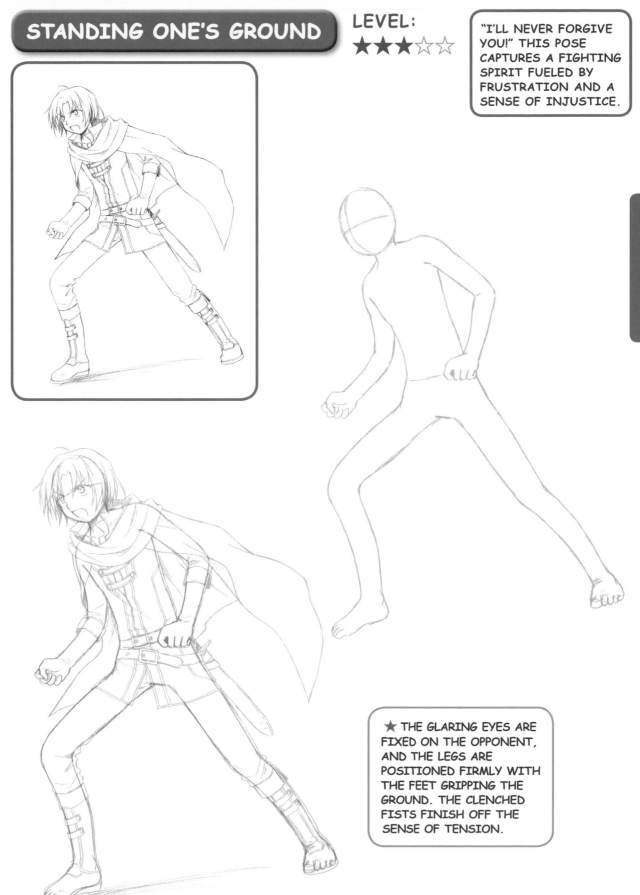

★ THE GLARING EYES ARE FIXED ON THE OPPONENT, AND THE LEGS ARE POSITIONED FIRMLY WITH THE FEET GRIPPING THE GROUND. THE CLENCHED FISTS FINISH OFF THE SENSE OF TENSION.

ENTERING INTO BATTLE

LEVEL: ★★★★☆

HERE, THE CHARACTER IS CRYING OUT AS HE RUSHES TOWARD AN OPPONENT. MAKE USE OF CLOTHING AND THE WEAPON TO CONVEY THE SENSE OF MOVEMENT AND SPEED.

★ MAKE SURE THE ARM AND LEG ARE NOT EXTENDING AT THE SAME TIME!

HUDDLED OVER IN PAIN

LEVEL:
★★★★☆

UNABLE TO BEAR THE PAIN, THIS YOUNG WOMAN SINKS TO THE GROUND.

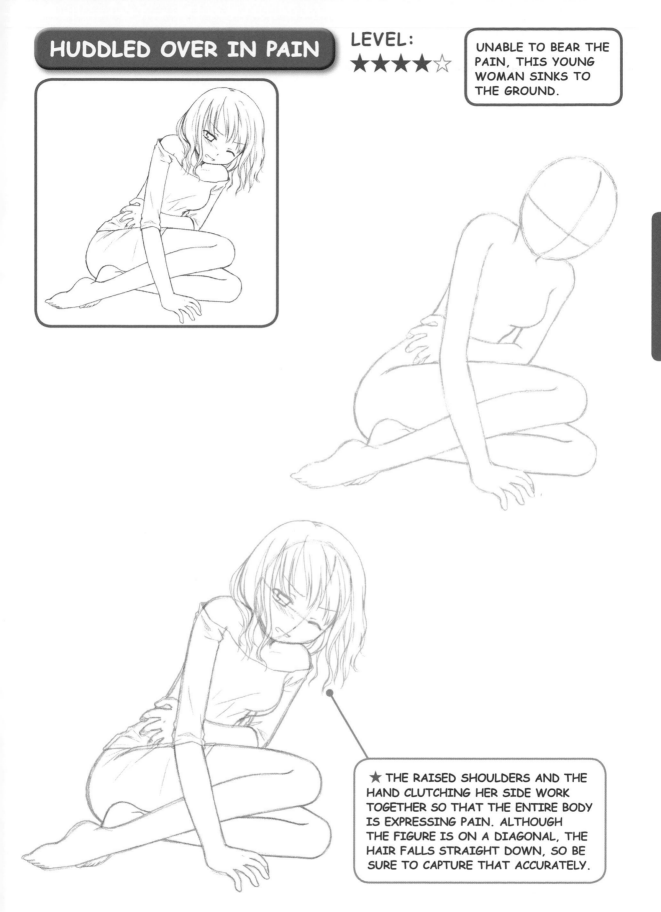

★ THE RAISED SHOULDERS AND THE HAND CLUTCHING HER SIDE WORK TOGETHER SO THAT THE ENTIRE BODY IS EXPRESSING PAIN. ALTHOUGH THE FIGURE IS ON A DIAGONAL, THE HAIR FALLS STRAIGHT DOWN, SO BE SURE TO CAPTURE THAT ACCURATELY.

HOLDING AN INJURED PERSON

LEVEL:
★★★★★

IN THIS TENSE SCENE, A CHARACTER CRIES OUT TO HIS UNCONSCIOUS FRIEND. MAKE SURE TO CAPTURE THE DESPERATION IN HIS FACE.

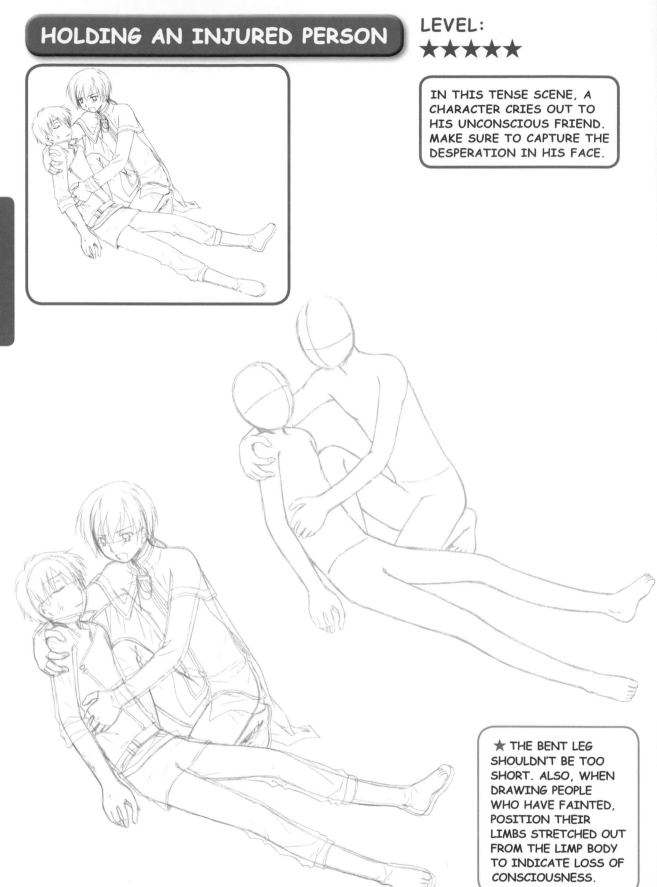

★ THE BENT LEG SHOULDN'T BE TOO SHORT. ALSO, WHEN DRAWING PEOPLE WHO HAVE FAINTED, POSITION THEIR LIMBS STRETCHED OUT FROM THE LIMP BODY TO INDICATE LOSS OF CONSCIOUSNESS.

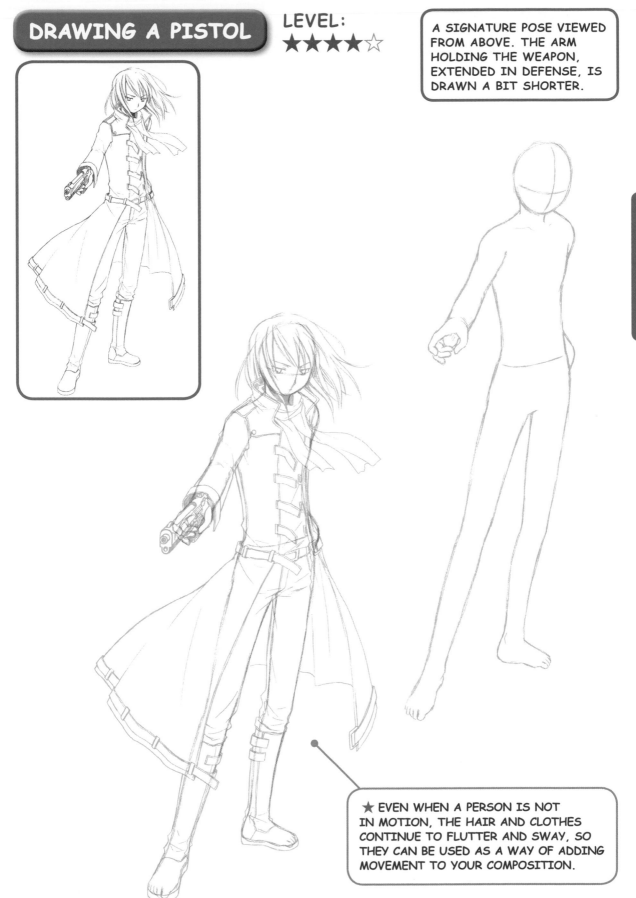

DRAWING A PISTOL

LEVEL: ★★★★☆

A SIGNATURE POSE VIEWED FROM ABOVE. THE ARM HOLDING THE WEAPON, EXTENDED IN DEFENSE, IS DRAWN A BIT SHORTER.

★ EVEN WHEN A PERSON IS NOT IN MOTION, THE HAIR AND CLOTHES CONTINUE TO FLUTTER AND SWAY, SO THEY CAN BE USED AS A WAY OF ADDING MOVEMENT TO YOUR COMPOSITION.

BATTLE SCARS

★ Adding scars and scratches to characters in fight scenes brings out the intensity of the conflict. Scrapes and abrasions on the face, arms and other clearly visible areas only heighten the tension.

NUMBER OF SCARS AND IMPACT

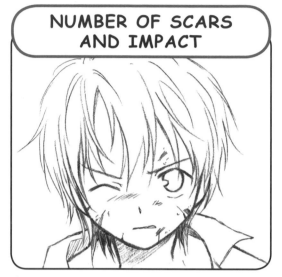

★ Several cuts and scrapes allow you to show that the fight is equally matched and has continued for some time.

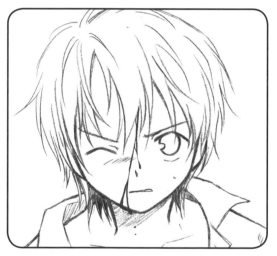

★ No scars are visible, but the blood dripping down is shocking.

THE POSITION OF SCARS TELLS A STORY

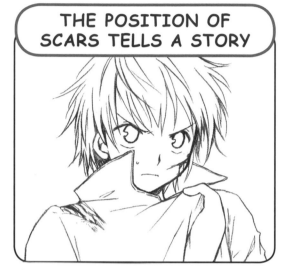

★ Deciding where the scars are located is a way to evoke the story of what happened before and after the fight on one sheet of paper.

★ Add scrapes, scratches and bruises if you wish and don't forget the wrinkles and folds in the shirt.

★ Clothing gets ripped and torn during a fight. Consider the scene and how the characters' clothes come into play. If they are caught on a branch, they'll tear in a ragged line and fibers will remain; if they are cut with a knife, the tear will be clean and straight; if they are involved in an explosion, they'll be scorched.

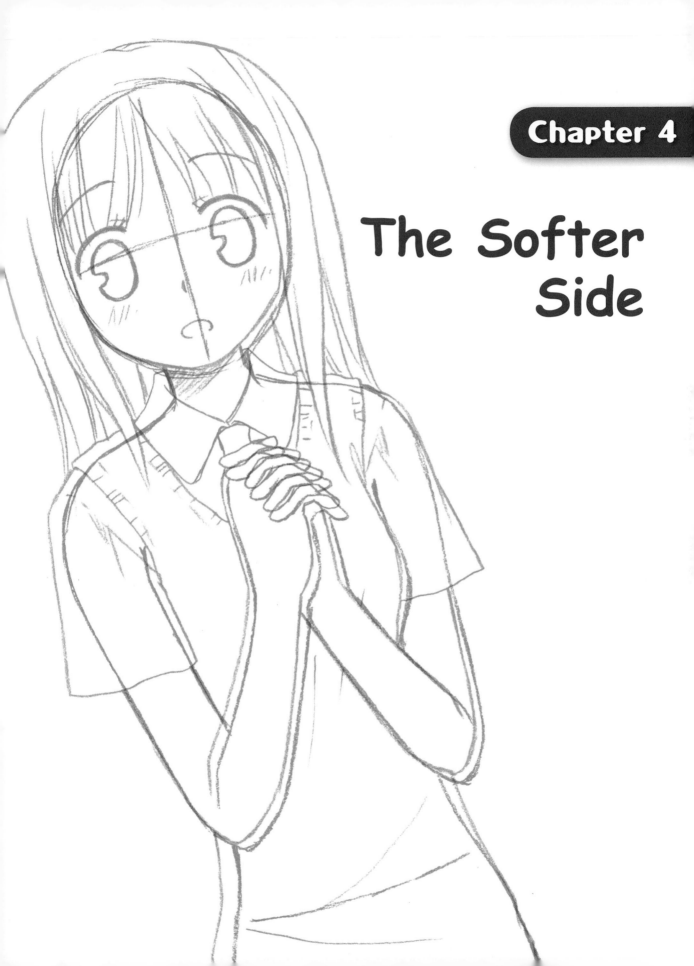

Chapter 4

The Softer Side

♥♥ BLUSH LINES ♥♥

♥ For scenes of love and romance, mastering the blush is essential.

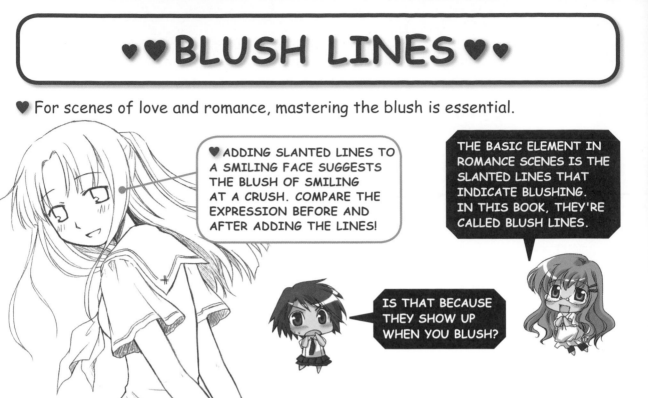

♥ ADDING SLANTED LINES TO A SMILING FACE SUGGESTS THE BLUSH OF SMILING AT A CRUSH. COMPARE THE EXPRESSION BEFORE AND AFTER ADDING THE LINES!

THE BASIC ELEMENT IN ROMANCE SCENES IS THE SLANTED LINES THAT INDICATE BLUSHING. IN THIS BOOK, THEY'RE CALLED BLUSH LINES.

IS THAT BECAUSE THEY SHOW UP WHEN YOU BLUSH?

TYPES OF BLUSH LINES

♥ FINE, THIN BLUSH LINES ARE SUITED TO DETAILED STYLES. MAKING THE EYES SPARKLE CONVEYS EVEN MORE EMOTION.

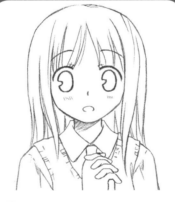

♥ SMALL, CHOPPY STROKES HELP DEPICT A CHARACTER IN LOVE. INDICATING A REDDENING OF THE CHEEKS CAN REALLY BOOST THE CHARM FACTOR!

♥ LARGE, SCATTERED BLUSH LINES SUIT ROUGHER STYLES SUCH AS IN BOLD OR CASUAL ILLUSTRATIONS.

MAKE BLUSH LINES DIFFERENT FOR MEN AND WOMEN

♥ Keep blush lines to a minimum for men, as adding too many can make for a lewd effect. Adding them to a woman helps convey that the couple are in love.

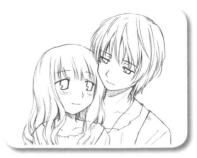

GETTING BUTTERFLIES IN THE STOMACH

WHEN DEPICTING EXCITED STATES, TRY SHOWING THE FIGURE NOT ONLY FROM THE FRONT BUT FROM THE SIDE TOO. THIS MAKES THE EYES APPEAR AS IF THEY HAVE JUST SPRUNG OPEN.

★ WHEN DRAWING THE FACE FROM THE SIDE, NOTICE HOW THE EYELIDS, EYEBROWS AND MOUTH BRING OUT THE DEFINITION AND FORCE IN THE EXPRESSION.

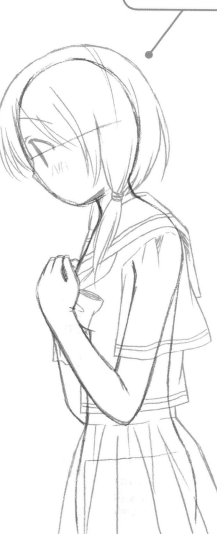

HANDS CLASPED IN ANTICIPATION

USED TO INDICATE SURPRISE, THIS EXPRESSION ALSO COMES IN HANDY WHEN CAPTURING DEEP ADMIRATION.

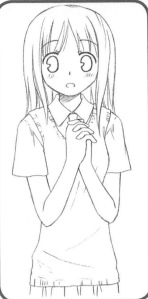

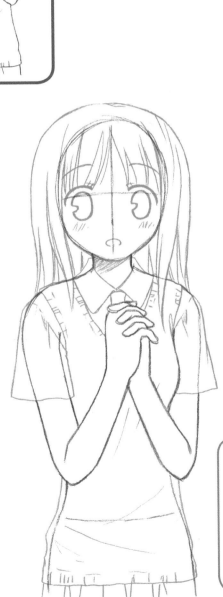

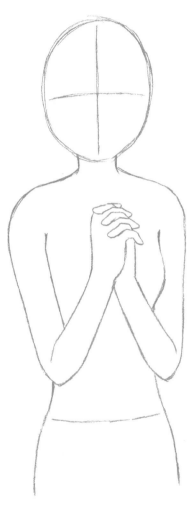

★ MAKE SURE TO DRAW EACH OF THE INTERLACED FINGERS SEPARATELY RATHER THAN IN A MASS. WHEN DOING THE BLOCKING-IN, FIRST ROUGHLY DRAW THE WHOLE HAND AND THEN FILL IN THE DETAILS.

4 The Softer Side

SCRATCHING THE HEAD FROM EMBARRASSMENT

LEVEL:
★★☆☆☆

THIS POSE SHOWS THE AWKWARD SHYNESS THAT ARISES WHEN A CHARACTER IS BEING FLATTERED BUT IS UNABLE TO ACKNOWLEDGE THE COMPLIMENT OR PAY ONE IN RETURN.

★ BLUSH LINES ARE THE KEY TO EXPRESSIONS OF SUBTLE SURPRISE (SEE PAGE 64).

CLASPING BOTH HANDS BEHIND THE BACK AND LOOKING OVER THE SHOULDER

LEVEL: ★★★★☆

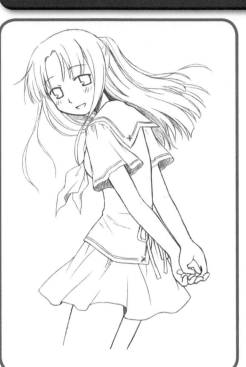

USE THIS POSE TO SHOW SHY FLIRTATION AS THE CHARACTER CASTS A SIDELONG GLANCE TOWARD HER LOVE INTEREST.

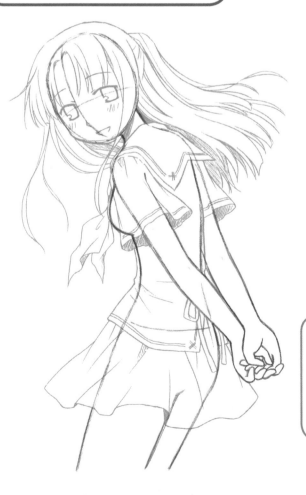

★ WHEN DRAWING THE BODY ON AN ANGLE FROM BEHIND, MAKE SURE THE NECK AND LEGS ARE IN THE RIGHT PLACE. MAKING THE CLOTHING AND HAIR FLUTTER ADDS TO THE GIDDINESS AND ELATION OF BEING IN LOVE.

WATCHING FROM THE SHADOWS

HERE, THE CHARACTER HAS WITNESSED SOMETHING SHOCKING. ADD SLANTED LINES TO THE FACE AND SWEAT TO SHOW PANIC AND USE GROUPED LINES TO INDICATE SURPRISE.

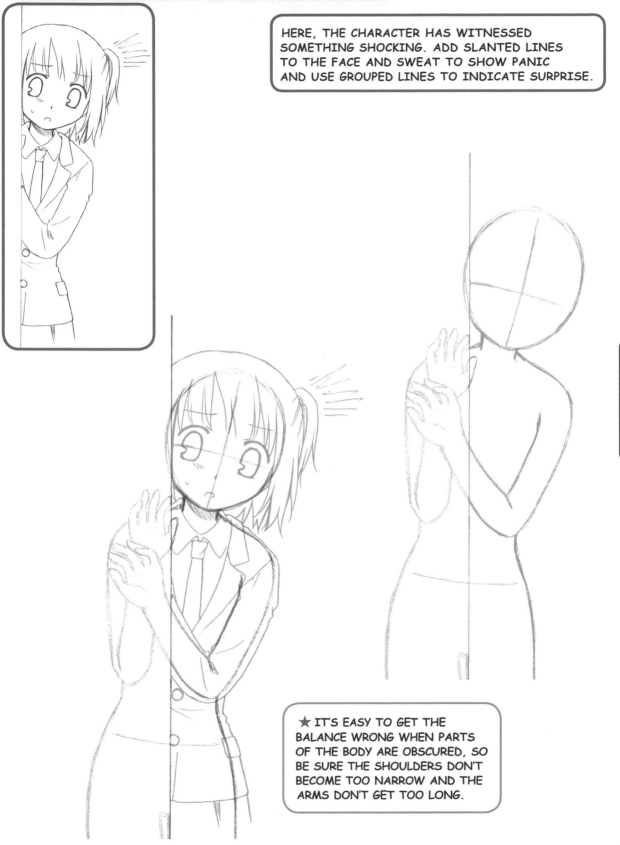

★ IT'S EASY TO GET THE BALANCE WRONG WHEN PARTS OF THE BODY ARE OBSCURED, SO BE SURE THE SHOULDERS DON'T BECOME TOO NARROW AND THE ARMS DON'T GET TOO LONG.

4 The Softer Side

EMBRACING FROM BEHIND

A POSE STRAIGHT OUT OF A ROMANTIC COMEDY: PAY PARTICULAR ATTENTION TO HOW THE ARMS CROSS OVER AND INTERLACE.

★ IT'S FINE IF THE COUPLE'S EYES MEET, BUT SHIFTING THEIR GAZE ADDS COMPLEXITY AND DETAIL TO THE STORY YOU'RE TELLING.

A KISS ON THE CHEEK

LEVEL:
★★★★★

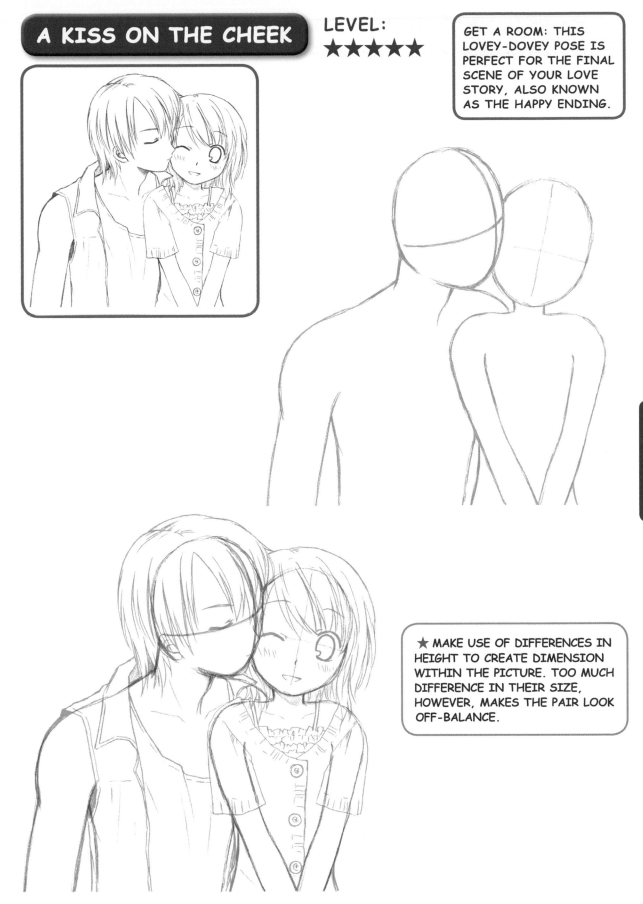

GET A ROOM: THIS LOVEY-DOVEY POSE IS PERFECT FOR THE FINAL SCENE OF YOUR LOVE STORY, ALSO KNOWN AS THE HAPPY ENDING.

★ MAKE USE OF DIFFERENCES IN HEIGHT TO CREATE DIMENSION WITHIN THE PICTURE. TOO MUCH DIFFERENCE IN THEIR SIZE, HOWEVER, MAKES THE PAIR LOOK OFF-BALANCE.

WHISPERING IN SOMEONE'S EAR

LEVEL:
★★★☆☆

JUICY GOSSIP SHARED IN THE SCHOOLYARD: IMAGINE WHAT THE SECRET IS AS YOU DRAW!

★ APPROACHED BY A BOY SHE'S INTERESTED IN, THE GIRL'S SURPRISE SHOWS IN HER WIDE EYES AND HER AWKWARD PLEASURE IS CAPTURED IN THE BLUSH LINES ON HER CHEEKS (SEE PAGE 64).

A PAT ON THE HEAD

LEVEL:
★★★☆☆

HERE THE HEIGHT DIFFERENCE IS USED TO GOOD EFFECT IN A SCENE SHOWING A GIRL WITH A CRUSH ON AN OLDER BOY.

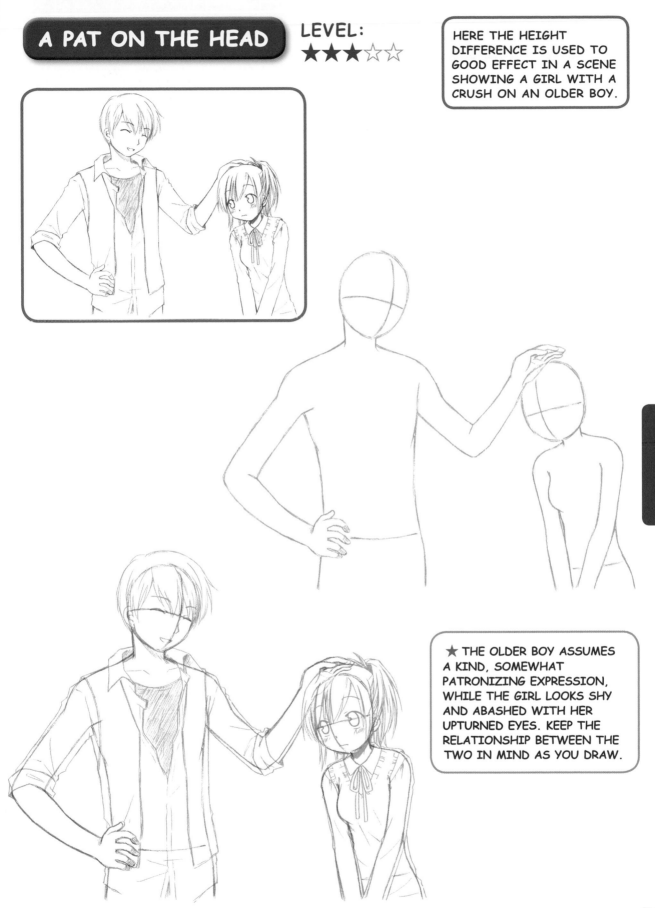

★ THE OLDER BOY ASSUMES A KIND, SOMEWHAT PATRONIZING EXPRESSION, WHILE THE GIRL LOOKS SHY AND ABASHED WITH HER UPTURNED EYES. KEEP THE RELATIONSHIP BETWEEN THE TWO IN MIND AS YOU DRAW.

CONFESSING FEELINGS OF LOVE

A "BUTTERFLIES IN THE STOMACH" MOMENT! THE SHOULDERS LIFT UNCONSCIOUSLY AND THE KNEES TURN IN.

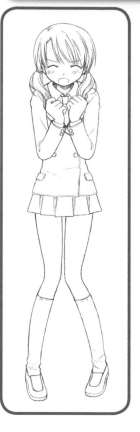

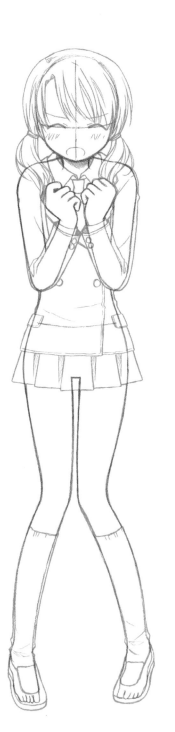

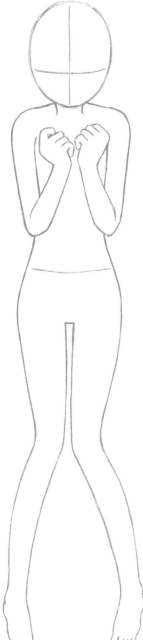

★ WHEN DRAWING A PIGEON-TOED STANCE, CONSIDER CAREFULLY HOW THE LEGS ARE POSITIONED AND WHERE THEY BEND.

ARRIVING AT A RENDEZVOUS

THIS POSE IS IDEAL FOR WHEN A CHARACTER BREEZES IN A FEW MINUTES LATE. MAKE SURE TO RENDER THE LIMBS IN A LOOSE, RELAXED WAY.

★ THIS POSE IS OFTEN USED FOR LAID-BACK CHARACTERS MAKING THEIR FIRST APPEARANCE IN YOUR STORY. IT'S IMPORTANT FOR ESTABLISHING PERSONALITY, AS YOUR CHARACTER NOT ONLY MAKES AN ENTRANCE BUT A FIRST IMPRESSION TOO.

4 The Softer Side

HUGGING A STUFFED ANIMAL

USE THIS POSE TO CONVEY THE SADNESS AFTER A BREAKUP OR AN ARGUMENT. THE KNEELING POSTURE PARTICULARLY SUITS A YOUNGER CHARACTER.

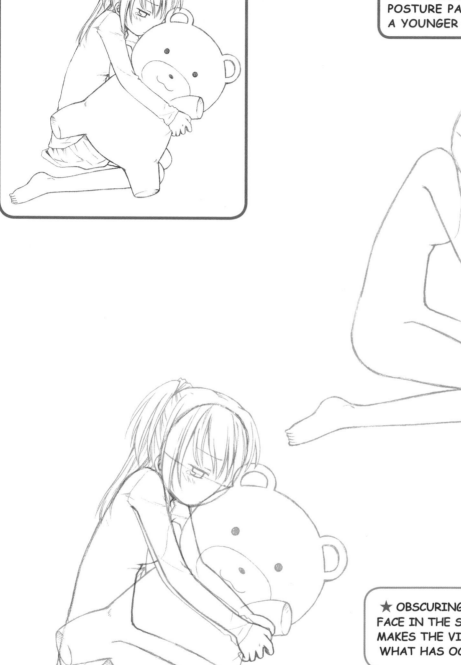

4 The Softer Side

★ OBSCURING HALF THE FACE IN THE STUFFED ANIMAL MAKES THE VIEWER WONDER WHAT HAS OCCURRED.

PLAYING KEEP AWAY

LEVEL: ★★★★☆

TEASING OR FOOLING AROUND WITH A FRIEND: USE THEIR EXPRESSIONS TO SHOW THE PLAYFUL NATURE OF THEIR FRIENDSHIP.

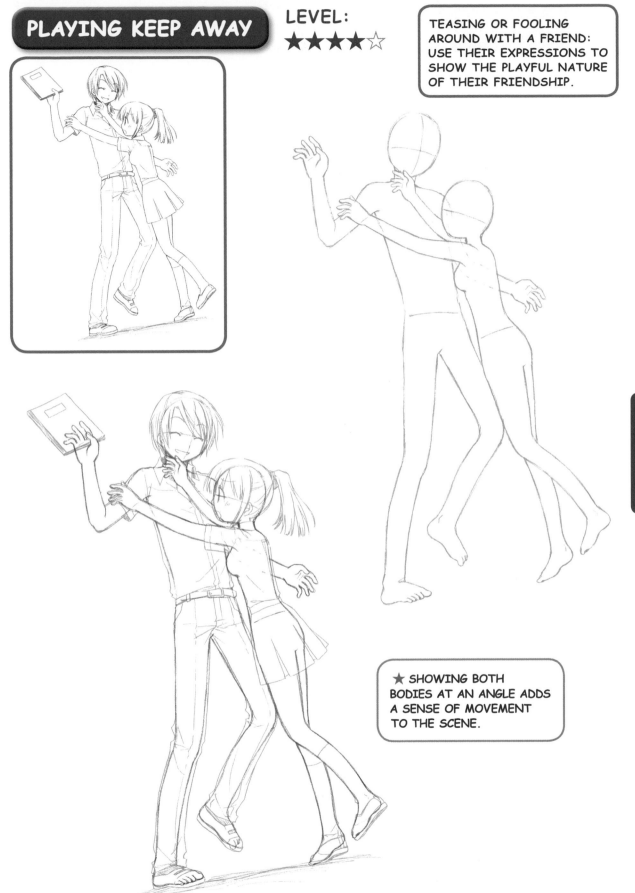

★ SHOWING BOTH BODIES AT AN ANGLE ADDS A SENSE OF MOVEMENT TO THE SCENE.

EMBRACING

LEVEL: ★★★★★

AT FIRST GLANCE, THIS APPEARS COMPLICATED, BUT A LOOK AT THE BLOCKING-IN SHOWS THE COMPOSITION OF THE PARTS LAYERED OVER EACH OTHER. PAY PARTICULAR ATTENTION TO DETAILS SUCH AS THE LENGTH OF THE ARMS.

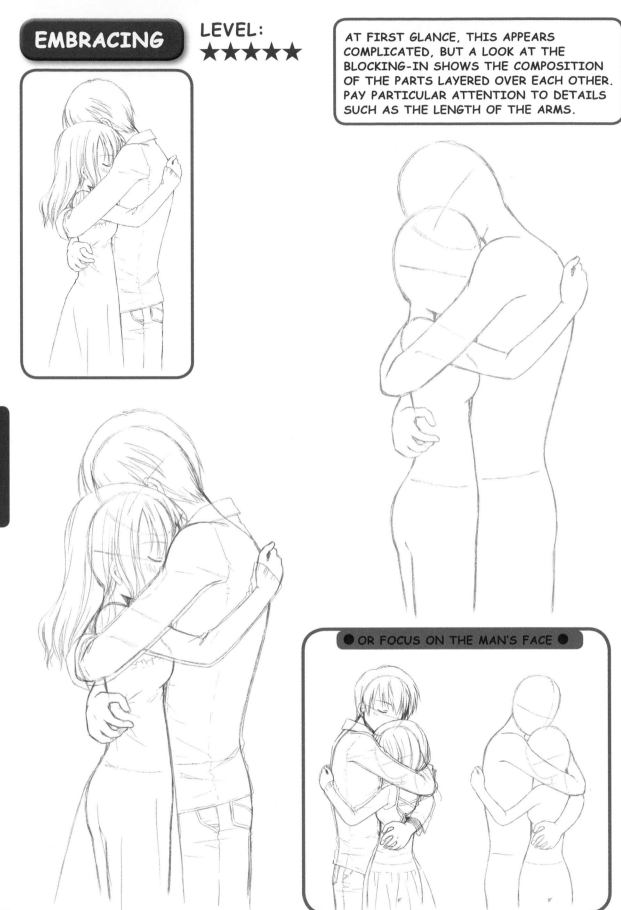

● OR FOCUS ON THE MAN'S FACE ●

A LEAPING EMBRACE

LEVEL:
★★★★★

IN THIS SCENE, ONE CHARACTER LEAPS UP AND WRAPS HER ARMS AROUND ANOTHER. THE MOVEMENT IN THE ENTIRE BODY MAKES FOR AN UNINHIBITED EXPRESSION OF LOVE.

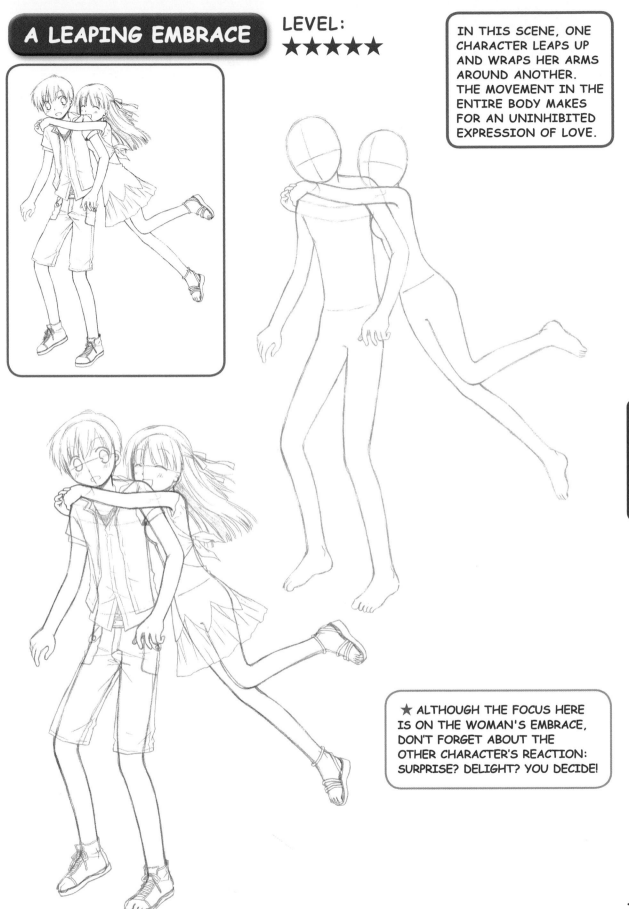

★ ALTHOUGH THE FOCUS HERE IS ON THE WOMAN'S EMBRACE, DON'T FORGET ABOUT THE OTHER CHARACTER'S REACTION: SURPRISE? DELIGHT? YOU DECIDE!

BLOCK IT ALL IN

★ When bodies overlap or are concealed by objects, failing to draw the obscured sections properly results in the torso becoming too long or the arms too short. Make sure to block-in even the sections that are not visible.

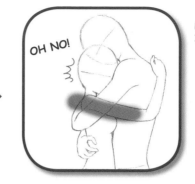

OH NO!

PHEW, LUCKILY I FIXED IT

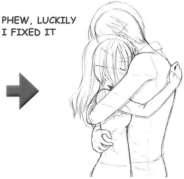

❶ A drawing in which the obscured body parts have not been properly conisdered.

Blocking-in the obscured parts reveals that the arms are too long.

Blocking-in the parts that can't be seen makes for an accurate drawing.

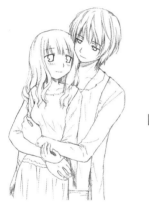

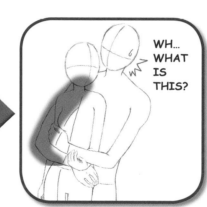

WH... WHAT IS THIS?

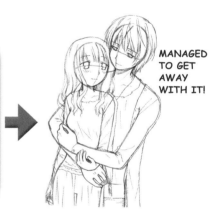

MANAGED TO GET AWAY WITH IT!

❷ Can you spot the mistake created by not blocking-in the entire figure?

Blocking-in the obscured parts reveals that the arms are too long in this picture too.

You'll thank yourself in the end for blocking-in even the parts that can't be seen.

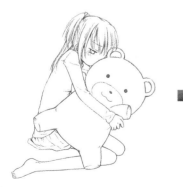

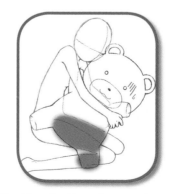

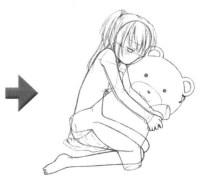

❸ Limbs can look oddly positioned or of the wrong length if not properly blocked-in.

Blocking-in the obscured parts reveals that the legs are too long and also out of place!

Remember when drawing a layered or overlapping pose, there's more than meets the eye.

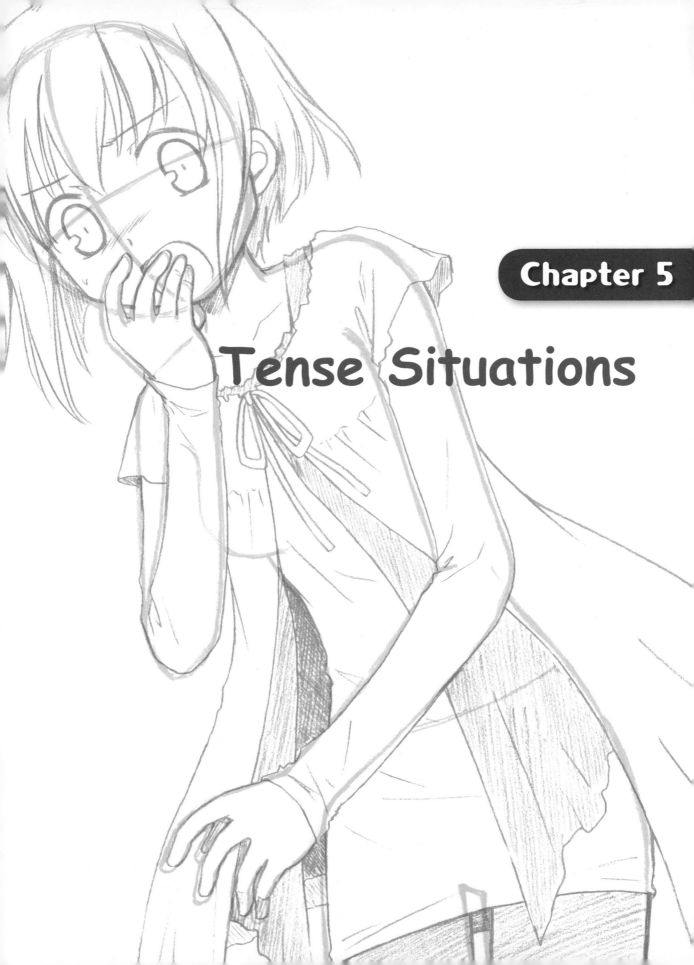

Chapter 5

Tense Situations

◆◆ THE HORROR! ◆◆

◆ With frightening, desperate or horrific scenes, bring out a different kind of tension by widening the eyes, contorting the facial features and adding shadowy effects.

◆ CONTORTING THE EYEBROWS AND MOUTH MAKES FOR AN INTENSE OR MANIACAL LOOK. WIDENING THE EYES AND TWISTING THE LINE OF THE LOWER EYELIDS CREATES A FRIGHTENING EXPRESSION.

ADDING SLANTED LINES TO THE UPPER HALF OF THE FACE INDICATES SKIN THAT HAS GONE PALE. THE EYES ARE EXTREMELY IMPORTANT FOR EXPRESSING EMOTION, SO MAKE SURE NOT TO OBSCURE THEM.

ALL EYES: REMOVING THE HIGHLIGHTS

A girl with highlights (light reflected in the eyes) in her irises. This makes for a slightly daydreamy, cute expression...

...but if you remove the highlights and add slanted lines to the irises, the sparkle disappears from the eyes, creating a lifeless expression.

WOW, REMOVING HIGHLIGHTS REALLY MAKES A DIFFERENCE!

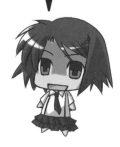

DRAWING A SHOCKED OR HORRIFIED EXPRESSION

◆ The more the face is contorted, the more shocking of an impression it makes. Adding bags under the eyes, shadow around the eyes and wrinkles to the nose creates a truly ghastly expression.

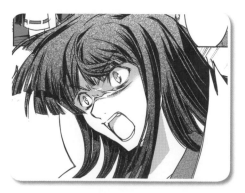

From the example on Page 15 ▶

5 Tense Situations

DAWNING REALIZATION

LEVEL:
★★★☆☆

THIS POSE SHOWS A CHARACTER SUDDENLY REALIZING THE FULL IMPORT OF SOME DARK DEED HE'S DONE.

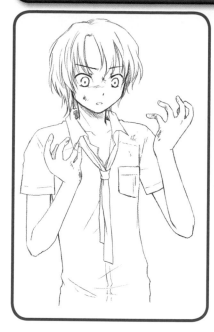

★ NOTICE THE COMBINATION OF SHOCK AND FEAR CAPTURED HERE. MAKE THE HANDS, FACE AND CLOTHES DIRTY OR DISHEVELED TO ADD TO THE SENSE OF TENSION.

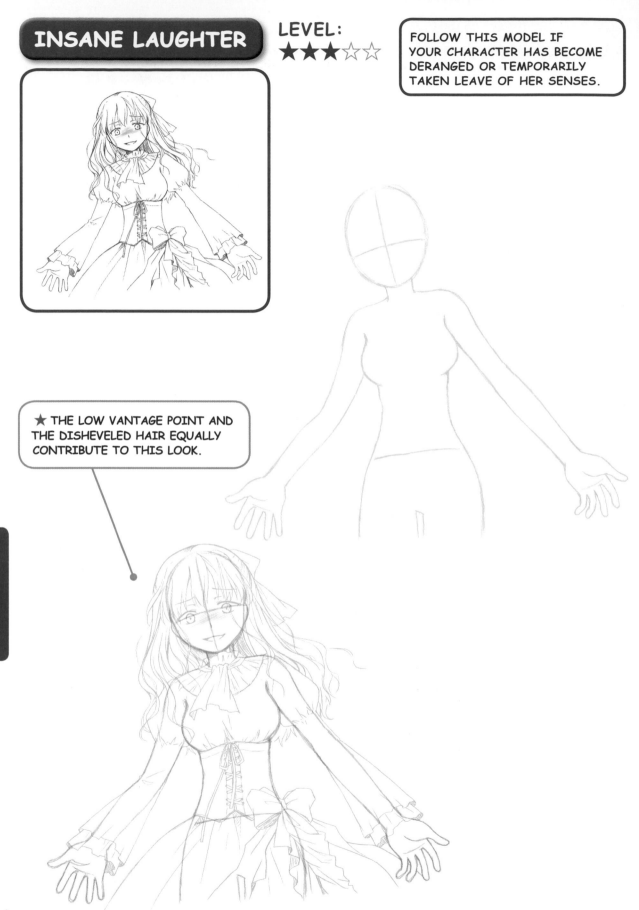

INSANE LAUGHTER

LEVEL: ★★★☆☆

FOLLOW THIS MODEL IF YOUR CHARACTER HAS BECOME DERANGED OR TEMPORARILY TAKEN LEAVE OF HER SENSES.

★ THE LOW VANTAGE POINT AND THE DISHEVELED HAIR EQUALLY CONTRIBUTE TO THIS LOOK.

LEVEL:
★★☆☆☆

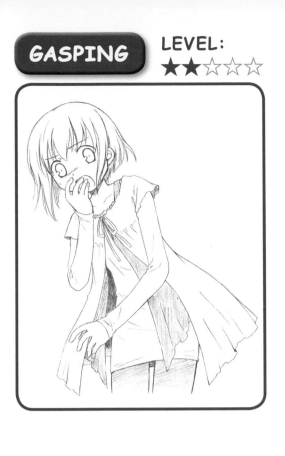

WHEN A CHARACTER SCREAMS AT THE SIGHT OF SOMETHING TERRIFYING, THE HAND IN FRONT OF THE MOUTH IS THE KEY, BUT THE GESTURE OF THE OTHER HAND IS ALSO IMPORTANT.

★ DRAWING THE HAIR AND CLOTHING AS IF THEY'RE BEING BLOWN BY A BREEZE FROM BELOW CREATES THE IMPRESSION OF HAIR STANDING ON END FROM FRIGHT AND SHOCK.

SHAKING WITH FEAR

HERE, THE BODY TREMBLES UNCONTROLLABLY IN FEAR. ADD A SERIES OF LINES TO EXPRESS CHATTERING TEETH AND AN UNCONTROLLABLE SHUDDER.

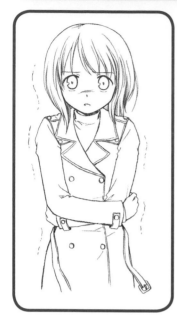

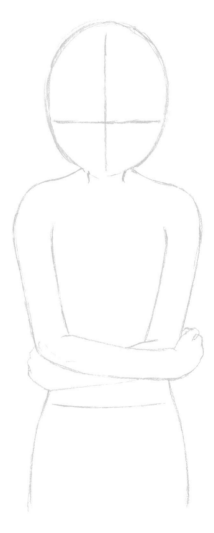

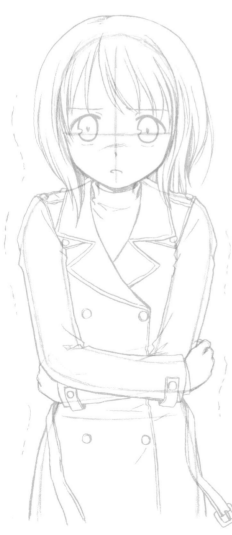

5 Tense Situations

★ MAKE THE PUPILS SMALL WITHIN THE IRISES AND ADD SLANTED LINES ACROSS THE NOSE TO HEIGHTEN THE SUSPENSE. WRAP THE ARMS AROUND THE BODY TO MAKE IT APPEAR TO BE LEANING FORWARD.

SLAPPING SOMEONE'S FACE

LEVEL:
★★★★☆

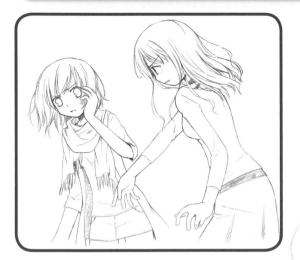

IN A FIGHT SCENE, CAPTURING THE AGGRESSOR'S SLAP OR PUNCH IS JUST AS IMPORTANT AS THE REACTION ON THE OTHER CHARACTER'S FACE.

★ IN A SCENE WHERE A CHARACTER IS BEING SUDDENLY AND UNEXPECTEDLY STRUCK, LOWERING THE EYEBROWS CREATES A LOOK OF SHOCK.

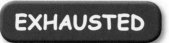

EXHAUSTED

LEVEL:
★★★★☆

OBSERVE YOURSELF WITH SLACK MUSCLES TO SEE WHAT KIND OF POSES ARE CREATED IN THESE SITUATIONS.

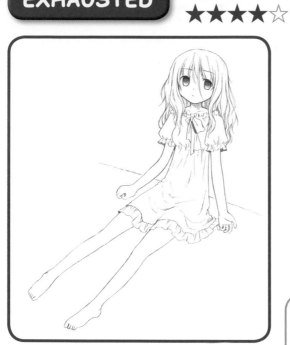

★ AS WE ARE UNACCUSTOMED TO SEEING THEM, LIMP LIMBS ARE SURPRISINGLY DIFFICULT TO CAPTURE. THE REST OF THE BODY LOOKS DIFFERENT FROM NORMAL TOO, WITH THE SHOULDERS SLUMPED AND SAGGING.

BACKED INTO A CORNER 1

LEVEL:
★★★☆☆

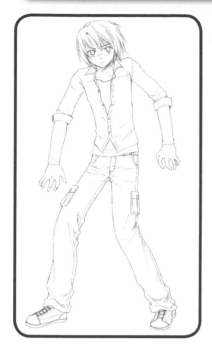

HERE, THE YOUNG MAN BACKS UP IN FEAR. THE SUBTLE CROUCH IN THE RETREATING FIGURE CAN BE HARD TO GET JUST RIGHT.

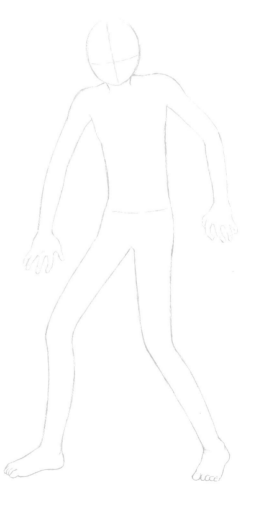

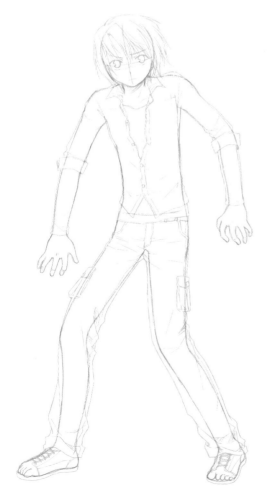

★ THE DESPERATE SITUATION SHOWS IN THE EXPRESSION FULL OF A SENSE OF DANGER. THE BODY TENSES, LIFTING THE SHOULDERS.

BACKED INTO A CORNER 2

LEVEL:
★★★☆☆

HERE'S ANOTHER VERSION OF THE SAME SCENARIO. ADD THE WALL OF A BUILDING OR A SIMILAR BACKDROP TO UNDERSCORE THE SENSE OF BEING TRAPPED.

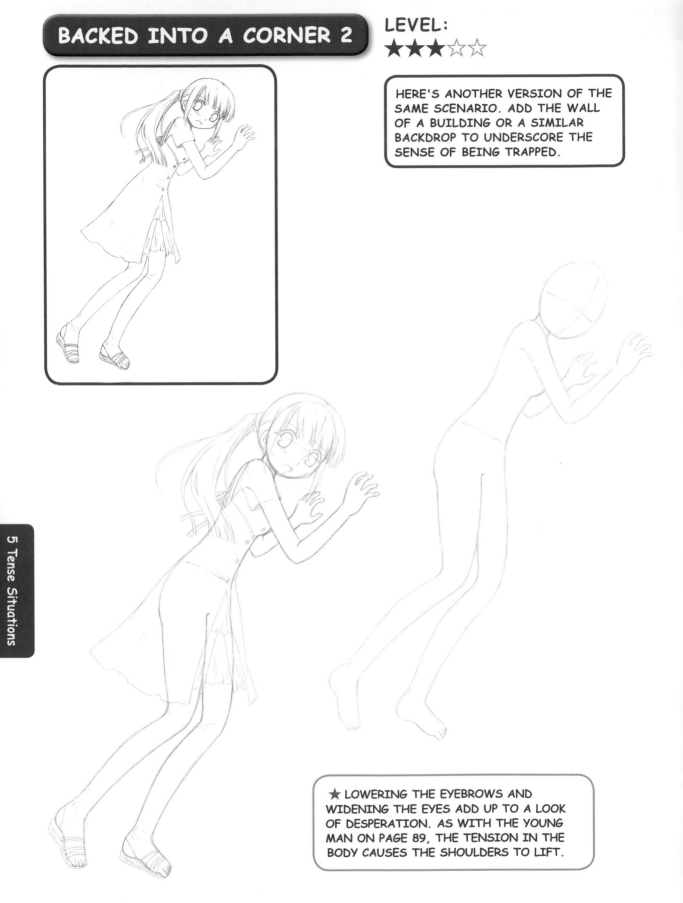

★ LOWERING THE EYEBROWS AND WIDENING THE EYES ADD UP TO A LOOK OF DESPERATION. AS WITH THE YOUNG MAN ON PAGE 89, THE TENSION IN THE BODY CAUSES THE SHOULDERS TO LIFT.

SHADOWY SUBJECTS

★ In scary or violent scenes, adding shadow to your characters' faces ratchets up the sense of tension. Consider which direction the light is coming from and add shadow effects accordingly.

WITHOUT SHADOW

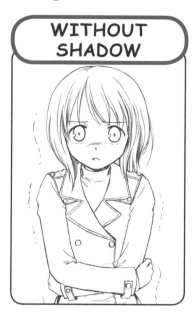

LIGHT FROM ABOVE RIGHT

LIGHT

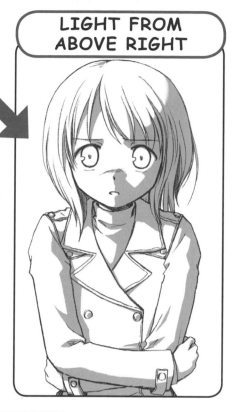

▶ This is one of the most common ways of integrating shadow. As the cheeks protrude, the light that hits them forms a triangular shape.

LIGHT FROM BELOW

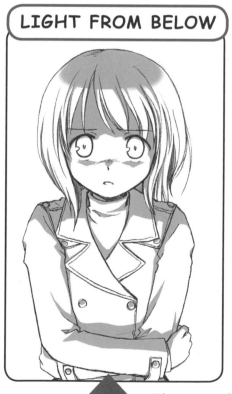

LIGHT FROM BEHIND

◀ Backlighting makes a character's expression difficult to see, so use it when you want to conceal the face or create a dramatic effect.

LIGHT

LIGHT ▲ This type of lighting is often used to evoke horror or suspense. When the light hits from below, it lends the scene an eerie or unsettling look.

WHAT IS CHIBI?

With chibi characters, proportions and expressions are altered and distorted for an exaggeratedly cute, comical or cartoonish effect.

★ Chibi style involves emphasizing or overexaggerating features and body parts. Altering its typical appearance allows a character or scene to take on a more offbeat or unusual appearance or impression. It's a technique typically used in humorous scenes.

"AGGGH!"

ALTERING A PICTURE'S PROPORTIONS IS ONE WAY OF DEVELOPING YOUR INDIVIDUAL STYLE!

VARIOUS CHIBI EFFECTS

WAAAH

SIGH

Exaggerate expressions for comic effect!

Suited to humorous scenes. Even though the girl is crying, the mood is kept light rather than getting too serious.

Exaggerate cuteness!

Make the character's head a third or even half the size of the body to create a cute, mascot-like character you'd want to take everywhere.

Exaggerate emotions!

Even in tense scenes such as when a character is in despair, this approach prevents things from getting too serious and lends an air of calm.

USE THESE AS REFERENCES FOR PRACTICING THE CHIBI TECHNIQUE ON YOUR OWN CHARACTERS!

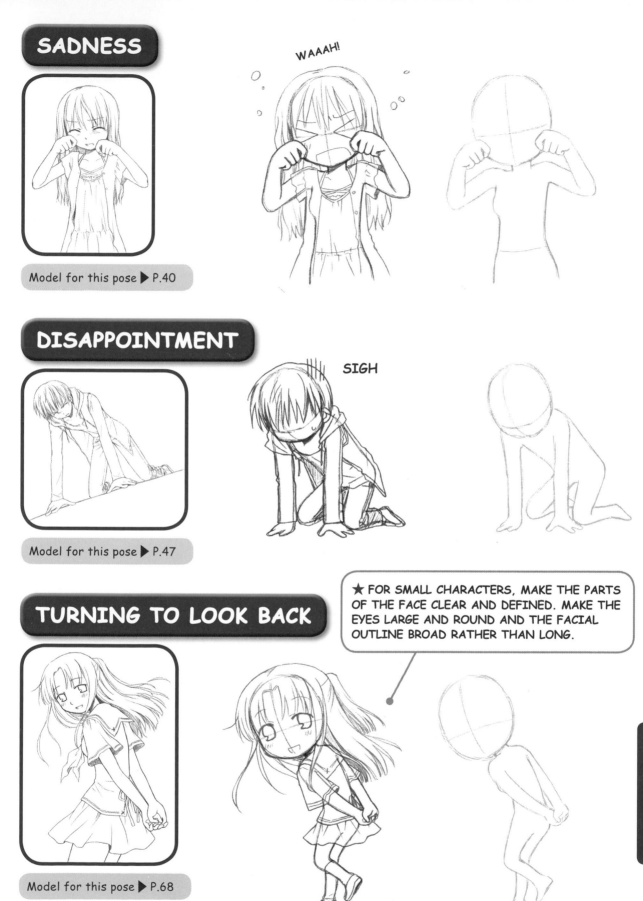

SADNESS

WAAAH!

Model for this pose ▶ P.40

DISAPPOINTMENT

SIGH

Model for this pose ▶ P.47

TURNING TO LOOK BACK

Model for this pose ▶ P.68

★ FOR SMALL CHARACTERS, MAKE THE PARTS OF THE FACE CLEAR AND DEFINED. MAKE THE EYES LARGE AND ROUND AND THE FACIAL OUTLINE BROAD RATHER THAN LONG.

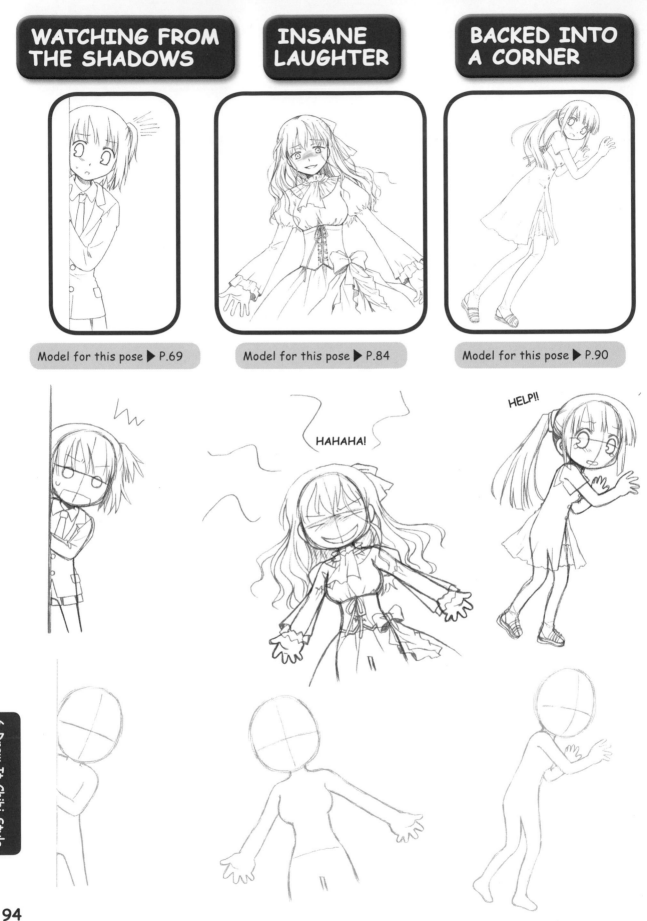

WATCHING FROM THE SHADOWS

Model for this pose ▶ P.69

INSANE LAUGHTER

Model for this pose ▶ P.84

BACKED INTO A CORNER

Model for this pose ▶ P.90

HAHAHA!

HELP!!

NOW LET YOUR IMAGINATION SOAR!

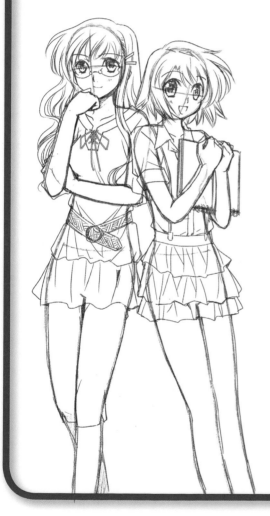

 Now your manga creations have assumed a new dynamic dimension and your characters can express emotion not just through their faces but using their entire bodies. And these techniques apply to more than just people of course—in the animal kingdom, dogs wag their tails when they're happy and when cats sense danger, the hair stands on end on their entire body. In the case of your human creations, the face alone can convey a lot, but adding body and hand gestures makes for a richer expression and more compelling scene. The endless combinations of facial expression and poses make for infinite possibilities when it comes to your storytelling and allowing your talent and imagination to soar!

"Books to Span the East and West"

Tuttle Publishing was founded in 1832 in the small New England town of Rutland, Vermont [USA]. Our core values remain as strong today as they were then—to publish best-in-class books which bring people together one page at a time. In 1948, we established a publishing office in Japan—and Tuttle is now a leader in publishing English-language books about the arts, languages and cultures of Asia. The world has become a much smaller place today and Asia's economic and cultural influence has grown. Yet the need for meaningful dialogue and information about this diverse region has never been greater. Over the past seven decades, Tuttle has published thousands of books on subjects ranging from martial arts and paper crafts to language learning and literature—and our talented authors, illustrators, designers and photographers have won many prestigious awards. We welcome you to explore the wealth of information available on Asia at **www.tuttlepublishing.com**.

Published by Tuttle Publishing, an imprint of
Periplus Editions (HK) Ltd

www.tuttlepublishing.com

ATARI KAKUMEI 2
Copyright © Junka Morozumi, Tomomi Mizuna 2010
All rights reserved
English translation rights arranged with MAAR-sha
Publishing Co., Ltd
through Japan UNI Agency, Inc., Tokyo

ISBN 978-4-8053-1571-2

English Translation © 2020 Periplus Editions (HK) Ltd.

Printed in Singapore 2112TP

24 23 22 21 10 9 8 7 6 5 4

TUTTLE PUBLISHING® is a registered trademark of Tuttle Publishing, a division of Periplus Editions (HK) Ltd.

Distributed by
North America, Latin America & Europe
Tuttle Publishing
364 Innovation Drive
North Clarendon, VT 05759-9436 U.S.A.
Tel: 1 (802) 773-8930
Fax: 1 (802) 773-6993
info@tuttlepublishing.com
www.tuttlepublishing.com

Japan
Tuttle Publishing
Yaekari Building 3rd Floor
5-4-12 Osaki
Shinagawa-ku
Tokyo 141-0032
Tel: (81) 3 5437-0171
Fax: (81) 3 5437-0755
sales@tuttle.co.jp
www.tuttle.co.jp

Asia Pacific
Berkeley Books Pte. Ltd.
3 Kallang Sector #04-01
Singapore 349278
Tel: (65) 67412178
Fax: (65) 67412179
inquiries@periplus.com.sg
www.tuttlepublishing.com